Tell Your Story with Light

The Basic Guide to Great Photos and Video

By Robert R Ducker

Copyright © 2019 Robert R. Ducker

All rights reserved.

ISBN-13: 9781070653358

Independently published

Disclaimer

Although the author and publisher have made every effort to ensure that the information in this book was correct at press time, the author and publisher do not assume and hereby disclaim any liability to any party for any loss, damage, or disruption caused by errors or omissions, whether such errors or omissions result from negligence, accident, or any other cause.

For my wife, Renee.

4

Acknowledgements

I thank my wife, Renee, who is a constant source of wisdom and encouragement. She led the way with her great book *Let the Middle Aged Lady Speak*, which is available in paperback.

Another who led the way with his imagination and writing skill is my good buddy John Heldon, author of *The Ark Saga*. At the time of this writing *Ark, Ark: Book IV Ghosts, Ark Book V: Beneath* and *Ark Book VI: Above* are all available as Kindle Books.

Introduction

This basic guide is intended for people who are just beginning to take their photography activities seriously.

I want to speak with the folks who think they can't take pictures and help them believe they could enjoy the creative process known as photography. I want to guide casual picture takers toward a quest to master photography as an outlet for personal expression.

We'll discuss do's and don'ts and Rules of Photography. I want you to know that you are the artist and the one to decide when to follow the rules and when to break them. All according to your artistic goals.

My YouTube Channel

https://www.youtube.com/c/TechVideosNET

Table of Contents

Ways to Enjoy Photography 13
 Landscape Photography
 Interior Photography
 Photographing People
 Videography
 More Ways to Enjoy Photography

Concepts for Creativity 35
 Flash Photography
 Depth-of-Field
 Image Composition
 Color Temperature

Creativity from Within 45
 Purpose and Process
 Motivation
 Roles of Photography
 Communicating through Photography

The Language of Creativity 55
 Quick Photo Tips
 Photographic Terms
 Mood Enhancers

The Tools of Creativity 71
 Cameras
 Smartphones

Smartphone Photography 73

Camera Body Types 79
 Point-and-Shoot
 Rangefinder
 DSLR
 Mirrorless

Photographic Lenses 85
 Normal Lens
 Telephoto Lens
 Wide-Angle Lens
 Nikon AF-S DX NIKKOR 35mm f/1.8G lens
 Macro Lens
 Zoom Lenses
 More Lens Types

Selected Photographic Equipment 93
 Sliders
 LED Video Lights
 Light Stands
 Diffusers and Reflectors
 3-Axis Handheld Gimbal Stabilizer

Photographic Accessories 99
 Photographic Filters
 Video Cage
 Batteries

The Extended Photographic Process 109
 Photo Editing
 Image File Formats
 Camera Manual Walkthrough

My Photography Story 127
 Getting Hooked
 My Minolta Film Camera

12

Ways to Enjoy Photography

Landscape Photography

The most basic definition of landscape photography is that it involves shooting natural subjects outdoors such a waterfalls, rivers, rapids, deserts, snow, fog, beaches, trees, fields, sunsets, and seasons. This definition of landscape work can easily be expanded to add 'cityscapes' including buildings, streets, bridges, statues, parks and so forth. You might even include images with people in them as long as the people blend into the scene or enhance the impact of the image by providing a reference for scale.

Recent interest in the work of photographers such as Peter Lik has boosted the status of landscape work. Peter's energy and drive to get the best landscape shots has helped to bring landscape photography back from decades spent in relative oblivion. It's not that photographers weren't motivated by the idea of being the next Ansel Adams. It's just that they couldn't talk about it with anyone else without boring them.

You might be motivated to impress family and friends with some photos of great natural scenes you've visited. Here's a tough question for you. How do you capture the grandeur of a scene that is a mile wide, full of natural detail and numerous subtle color shifts while dealing with issues? related to lighting and contrast? I should also remind you

that your audience might be viewing your image in an electronic format as small as 5 inches measured diagonally.

Beyond the technical basics of assuring that you have set the exposure and shutter speed to produce a viewable image and assuming you have composed the picture area in a satisfactory way, there are a few additional considerations that can make your new landscape photo great. You don't need to squeeze all of these ideas into each shot. Just one of these improvements can be enough to make the difference.

Focal Point - Landscape photos require a focal point to attract and hold viewer interest. A fallen tree within a forest scene, a pier along the beach and an old covered bridge near a stream are examples.

Include the Foreground - Including foreground elements can improve some landscapes by giving visual clues about depth while adding a focal point. You might include an especially interesting subject such as a horse, small building or a piece of farm equipment thus creating a smaller composition within your larger scene.

Depth - Enhance your pictures by indicating depth. A road that leads deeper into the shot, railroads or streams are all good choices but are not always available. Choose a foreground object that it is far enough away to be in focus with the background. This is all related to the concept of diminishing perspective where the further objects are placed from the camera the smaller they appear. The effect will

become more apparent in cases where you are shooting rows of similar objects. The viewer's mind will determine that these objects are the same size, while adding a sense of depth to the photo. This technique works well with street photography.

Converging Lines is another way to describe the above effect and is another popular way to add a sense of depth. The edge lines of a road or the rails of a railway are examples of lines that are known to be parallel, but the further they are from the viewer the more they appear to converge toward each other until they appear to meet at a vanishing point. These converging lines in photo tend to draw the eye through the frame thus creating a sense of depth.

Varying Light Values by Distance is another technique. This could be called layering. Remember pictures you've seen that contain succeeding rows of hills each further in the distance and each more distant row is a different shade of green or blue? Shooting through light brush in a rural scene or past a shorter building in a cityscape is another method to add a sense of depth to your shot.

Overall Uniformity of Light, Color, Contrast and Shading - There is a particular genre of landscape photograph that is defined by how the photographer chose to convey the various colors and the qualities of shading contained within the scene. A scene composed of colors or contrast values that don't vary greatly from edge to edge can serve to connect all the picture elements into one coherent theme. Scenes with

many buildings all in the same quality of light or of a grouping of trees of the same type are examples. Shooting during fog, rain, sunrise or sunset are possible ways to impose greater overall uniformity of light values, colors, contrast and shading upon a scene that would not otherwise present such properties. Utilize that consistency to form a strong message.

Natural Light Considerations

For landscape composition be conscious of how you are dividing the space between sky and land. A large sky may be what you want but it will also tend to darken the exposure of the land. Setting the horizon high to include mostly land will highlight elements such as waterfalls. Just be sure your sky is not washing out from overexposure in these situations.

Your best times for shooting outdoor natural daylight photos is up to about 10 AM and then after 3 PM. It's all about lighting and the position of the sun. Around noon it's very difficult to get pleasing photo results outdoors. If you are there for a while, try the experiment of shooting the same scenery at different times of day. I've always been intrigued by finding ways to 'paint' a scene with nothing but natural light. I have nothing against flash, but natural light shots are much more of a challenge with rewards that can be commensurate to your efforts.

Interior Photography

Flash photography may be the most popular mode of taking pictures because so many important events take place indoors. People love documenting the activities of their family and even their pets around the house. With birthdays, weddings, anniversaries and holidays a lot of special occasions happen indoors.

The standard flash shot is straight forward. Place the subject well within the range of coverage stated in your flash's manual. Check to see if you have a reasonably uncluttered background that won't detract from your subject. Help them to pose in a way they prefer and then shoot. When you have the opportunity to experiment try including the light from a window to reduce the harsh shadows produced by the flash and to help illuminate the background more evenly.

Next, try to supplement your flash by placing light sources such as lamps at different angles off camera in front of the subject as well as toward the background if you can. If you can make a scene more evenly lighted the result will be more pleasing. There are differences in the qualities of the color of light produced by daylight, incandescent lights, LEDs and fluorescent bulbs including the newer compact fluorescent lamp that's replacing incandescent bulbs. These differences will show up in your pictures and may not always be pleasing.

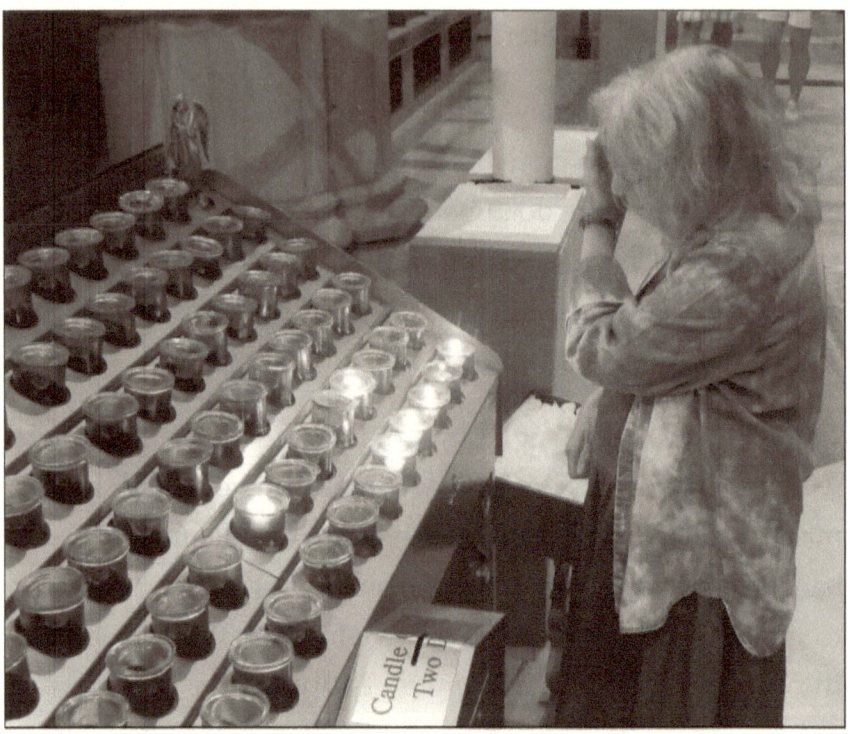

There are ways to partially compensate for this problem. Look for daylight balanced CFL bulbs at stores such as Lowe's and Home Depot.

LED lighting is commonly available in a range of products that matches or exceeds that of incandescent or CFL technology. The camera lights you buy for stills or video are almost certainly based on LEDs. Camera lights should have their color temperature, or their range of possible color temperature values, listed clearly in ads and on the box. Some lights will utilize colored filters to change the color temperature of their light.

About a Camera's Color Balance Settings

When you can't choose the lighting for your pictures, try adjusting the color balance as needed with your camera settings. This affords another opportunity to achieve the color balance you want. Most cameras feature automatic color balance adjustment. Your last chance to adjust color balance is during the photo editing process.

For your personal, possibly mobile, photography studio there are whole lighting systems available that are portable, powerful and surprisingly flexible to many situations. They provide features such as off camera flash, a second flash, bounce flash and umbrellas that bounce an even and constant light. You'll be able to choose the color temperature you need for each situation. You can expect to get professional portraiture results from these setups, after you learn to use them properly.

Photographic lighting is the easiest and most reliable way to take indoor pictures. There are other ways. When you're feeling particularly creative try existing light.

Existing Light Indoors

Existing light means the light sources that are in the room regardless of your intention to take a picture. Examples are electric lamps, fireplaces, candles and the natural daylight coming in through a window. If you're tempted to move the existing light sources around or to pull the curtain at the window to get better results that shouldn't be a problem.

Your camera's flash will have to stay turned off in its case until we discuss 'fill flash'. You can achieve superior results using existing light and your motivation is the challenge to make it work for you plus the unique pictures you'll produce. There is another issue to consider with multiple existing light sources and that issue is shadows. To head off this problem practice looking at both the lighted areas and the shadow areas on your subject. Remember each light source is casting shadows somewhere on your subject and they will not always be complimentary.

Since you are working only with existing light you may be required to move things around a bit, including your subject if possible, or find ways to vary the intensity of some light sources. For example, you might be able to place a white piece of paper between an offending light bulb and your subject to produce a softer and more pleasing light source.

This is my picture of the interior of an old bus terminal. The area is way too large for flash. The various lighting sources are actually in conflict in some ways. Any time you have large amounts of bright sunlight flowing into an area other light sources will tend to be washed out. That's not the biggest problem in this picture. From my point-of-view the big problem is the greenish cast from the many florescent light fixtures in the area.

Later we'll discuss using filters to overcome some lighting issues. Fluorescent filters will help improve the greenish cast from fluorescent bulbs. Because not all florescent bulbs are

the same this filter will give variable results. As mentioned above each light source has its own characteristics to consider such as intensity and color temperature. How to compose the image and what settings to use can be very much a judgment call on your part and that process improves with experience and by knowing your equipment.

In the shot above the shutter speed was set slow to allow for the greatest possible depth of field. This is a handheld shot. A tripod might have been a good idea here. Digital cameras don't always have an automatic setting that deals with conflicting light sources adequately. If you have a camera that allows manual settings learn how to apply the right settings to get the results you want.

I consider my Fallingwater interior shot to have two light sources. Since Fallingwater is in a wooded area and also in a valley there is a small amount of direct sunlight and a lot of daylight that is indirect and scattered. I suggest a basic shot composition that includes some of the view out through the window and then follows the sunlight onto various interior elements such as the mirror and the wall. The view out the window only needs to suggest trees so the sharpest focus will be on the interior objects receiving the sunlight. The section of wooded area that shows is too bright.

Tips for Working Indoors

Limited Space - Another consideration for shooting indoors is dealing with limited space. A wide-angle lens will provide

the effect of backing up 20 feet, for example, in an apartment that only gives you 10 feet of working room. However, don't overlook the possibility of rearranging the furniture temporarily as another option to get your shot.

Clean Up the View - Working indoors gives you improved ability to control the view and to remove unwanted elements. Look closely and you may spot a piece of paper, a power cord, or some other object that detracts from your image. Indoors you often have the option to move such items while you take the shot.

Props - you might bring an object or find an object in another room that improves your shot. That item could be a pet, an attractive rug, a vase with flowers or whatever you think belongs in the view.

Consider Your Stance - It is often helpful to think of several final items behind the lens before you shoot: hold the camera straight and choose you best vantage point whether it be against a wall or halfway up a staircase. Try to shoot from a high angle for some shots and decide if that angle improves the general aesthetics of the image.

Photographing People

One goal you may have when it comes to shooting people is to grab great shots of them doing the interesting things that they normally do when no one is watching rather than just posing for the camera. We'll try to make a short list of things you could try. The bottom line for me is that people who are

consistently producing great shots of other people are successful more because of their innate personal skills and way of relating than due to any skills in the technicalities of photography.

One item you should add to your camera bag is blank model release forms that will be signed by the subject of the photograph and that will grant you permission to publish the photograph (in case you want to do that). They may not be needed in all situations, but you must research this topic and all the related legalities regarding your intended purpose. Do that before you set out to photograph strangers.

Every photographer knows this situation. You come upon a group of people and you see some interesting photo possibilities. As soon as you pull out your camera everything stops. Some people put their hands up over their face and others complain that they don't want their picture taken looking the way they do. Some people may look like

they want to punch you. The opportunity to take some great pictures is gone before you can get off one shot.

So, what are the alternatives?

A telephoto lens is a possibility for public places such as beaches and city streets. You can stay at a distance from the subject and not trigger any response to the camera. Even a moderate telephoto in the range of 85mm to 110mm could do the job. A more extreme telephoto will be bulkier, may require a tripod and it will be clear from the pictures that they were taken by a telephoto lens.

Those who are skilled with image processing can pull a clear photo of one or two individuals out of a general street scene. The photographer usually knows how they intend to use the photo when they take the shot. Another method is to blend in with your intended subjects for some time and then raise the camera when people are not so guarded. Most photographers who utilize this method recommend offering to share the results with the subject when that is feasible. This will allay concerns that you are presenting them in negative way and will become the groundwork for improved results in the future.

The easiest method is to put yourself at a place where there are a lot of tourists and you see cameras everywhere you look. You won't be noticed. And, you might get some people pictures that you like. You may aspire to join the Paparazzi and specialize in the quest for candid shots of famous

people. There are magazines full of shots taken by this group and some were well paid for their effort. My guess is that it's not always as profitable or as glamorous as people imagine. For this occupation you should add good medical, liability and accident insurance to your camera bag.

More about People Pictures

a. A picture with one or two individuals is usually more powerful than larger group shots.

b. Get up close but not up their nose.

c. For sports shots you'll need a faster shutter speed so be aware of depth-of-focus issues and the possibility of introducing graininess into your picture.

d. Take pictures of the other members of a rafting party. In that situation don't forget to do your part with the paddling and hopefully you'll have some notice when the raft is about to flip. Pack a heavy plastic bag to help protect your camera from water.

e. You might try asking the potential subject about their hobbies and then encourage them to show you their hobby while you take pictures.

f. Same as "e" above but get the person talking about their pet(s) and you might get interesting shots of human - pet interaction.

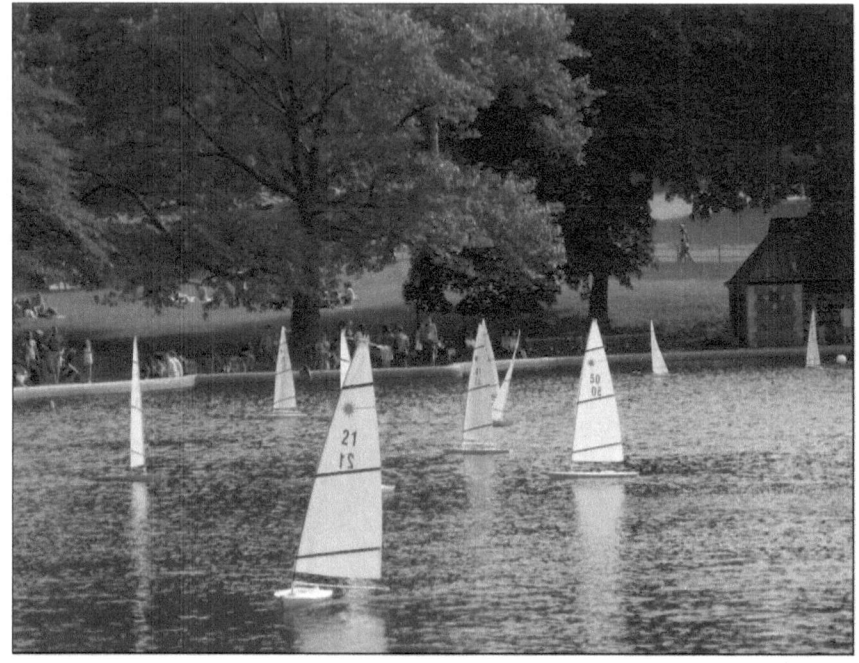

Videography

Shooting video is all about telling a story with light. When you shoot with still photography you get your picture. That was your opportunity to convey what was happening and why you thought it was important enough to take a photograph. Thinking of it this way makes still photography seem risky and difficult.

With videography you can show your audience what happened before and after the slice of time the photo represents. With videography you can put the full story before your audience.

The Three Phases of Videography

A videographer captures moving images on digital media. Videography includes methods of video pre-production, production and post-production. Below are only general descriptions of what typically happens during the **three phases of making a video.**

Pre-production involves, but is not limited to, tasks such as setting up electrical and passive lighting equipment, making and arranging any foreground and background elements in the shooting area, organizing and setting up cameras and inventorying and making-ready accessories such as batteries and cables. If you have live actors, you will have already prepared a script or even a basic screenplay with choreography.

Production is where you shoot and re-shoot the scenes you need to tell your story. Even an individual YouTuber will arrange for a B-roll. Production involves the video recording of an activity such as a product unboxing, a product review, an interview, the preparation of a recipe, tearing down a piece of electronics or a dance routine. During production it is common to stop recording during long, boring tasks, to reshoot portions of the presentation that are crucial to success or to reshoot after an interruption.

The Post-Production Phase is where you review the video you've captured and then proceed with the process of editing for a final video production. It's possible that you'll

want to return to production mode to shoot more video in cases where you don't have all the pieces you need. After you've edited all the scenes and possibly added music or B-roll and added the intro and the outro, you're ready to begin rendering. Rendering ends with your finished video. Next, your process may involve uploading your video to YouTube or otherwise starting the promotion phase.

Variations on the Process of Videography - Even of a YouTuber sets out walking and live streaming on downtown streets, you should still be able to identify the three phases described above in abbreviated form. In addition to recording video with a camera, videography can include activities such as digital animation, recording video gaming, live streaming and video blogging.

Audio for Videography

General Tips for Using a Microphone

1. Position your microphone as far as possible from reflective surfaces.

2. Aim toward the person speaking (or other target source) and away from undesired noise sources.

3. Don't cover any part of the microphone grille with your hand because that will block the sound.

4. Speaking / Performing near the microphone improves bass response.

5. Use no more than one microphone for each sound source.

6. Use a windscreen for outdoor microphone work.

7. If you hold the mic be careful not to move it in ways that will make bumping or mechanical vibration sounds during your recording. That's very irritating.

Easy Video Lighting Tips

1. If you plan to shoot in your studio often, studio lighting kits make for a versatile first choice. They often use large florescent lights and include diffusion material.

2. Kits with included light stands can be a good idea. Flimsy light stands are not worth your money and will serve only to aggravate.

3. Especially when you're a newbie, shoot test video whenever possible. A camera often requires more lighting than you can estimate with your eyes. Test video shots may reveal lighting problems you didn't notice.

4. Make certain your studio is ready before you start. Visit remote sites to check them out for potential lighting and sound issues whenever possible.

More Ways to Enjoy Photography

Drone Photography, Underwater Photography and Sports Photography are three more ways you can enjoy photography while telling your story with light. There's a great amount of overlap and mixing with the methods we've already discussed. Sports photography has a lot to do with photographing people. Drone photography and underwater photography still cover wide landscapes and outdoor scenes, although one is wetter.

With all their similarities, each has its specialized equipment and unique considerations. While taking photos underwater, you must remain aware of your surroundings and your relationship with the surface. Drone photography involves following complex flight rules while exhibiting consideration for others.

Drone Photography

Drone photography introduces you to a new and exciting way to view landscapes and cityscapes. If you're unlicensed and in the United States, you'll be flying legally below 400 feet. That's high enough to grab some spectacular video.

Talking to other drone operators and browsing online maps are two ways to scope out great locations for photography. Many drone models come equipped with good quality cameras. Did I hear Hasselblad? Drone photography can add a new dimension to your photography.

Example drone equipment: DJI Mavic 2 Pro with Fly More Combo Kit

With this drone you can shoot professional-quality images. You'll want the 20MP Hasselblad L1D-20c gimbal camera which features 1" CMOS sensor with an aperture range from f/2.8 to f/11. It supports a 10-bit Dlog-M color profile and 4K 10-bit HDR video capture. The Mavic 2 Pro delivers ghost-free images, low-light images, quiet operation and much more.

I listed the DJI Mavic 2 Fly More Kit because it adds many helpful accessories for your drone such as intelligent flight batteries, low-noise propellers, a shoulder bag, camera filters, cables, microSD cards and remote controller.

Underwater Photography

Underwater photography can involve wide landscapes, close ups and macro shots and action scenes. Using a flash or LED lighting can reduce the loss of colors such as red or orange which are partially absorbed by water. This effect becomes stronger the deeper you go. Water introduces problems such as distortion, color shift and reduced contrast. It's best to get as close to your subject as possible to reduce these effects. You can improve underwater images by dropping to the level of your subject rather than settling for a shot from above. Take some practice shots whenever possible to check out issues such a white balance.

The camera you use now may be suitable for underwater photography. Search around to see if anyone offers a waterproof case for your model.

Sports Photography

Sports photography is a big topic. For some people it means skydiving, snowboarding and football. This topic could also include auto racing, golf and a Bocce Ball Tournament.

We can discuss some general considerations for sports photography. First, review what we've already covered about photographing people.

In most cases a photographer wants to be as close as possible to the sports action without becoming part of it. Follow the action, use continuous shooting during the action scenes, have lens options available with at least one telephoto, set a fast shutter speed and set ISO to 400 or higher.

Of course, high quality zooms lenses are a top choice for sports photographers due to their ability to quickly switch from close-up action in front of the photographer to action that has suddenly moved to the other side of the field.

As you can imagine, you'll want a high-end camera model with fast autofocus and the high burst rates required for many sports.

Next, learn when to break all the rules above. For example, be alert to player actions or interesting situations away from the action. Shoot high quality still shoots with narrow depth-

of-focus when appropriate. You must know your sport and you better be prepared to set different parameters for games in bright sunlight versus games a night or indoors.

The sports photographer will often choose DSLR cameras with high continuous shooting speeds. The lens choice should include focal lengths from 16mm to over 500mm.

I see sports photographers using a monopod for a steady shot and lots of extra batteries. Lens choice plays a critical role in sports photography. For most sports you'll want the fastest lens you can afford. The requirement can be prohibitively expensive for very long telephotos and high-end zoom lenses.

My research says that the best cameras for sports photography available today are the Canon T6i, the Nikon D500 and the Sony a9. There are many additional specialty tools for sports photographers that will require research well beyond my knowledge.

Concepts for Creativity

Flash Photography

The common point-and-shoot camera and its built-in flash make a great combination. Read your manual to determine the optimum distance to the subject that your flash will support and always keep that distance in mind when using the flash. Be prepared to wait for the recycle time between shots.

Shooting a group of people can be a problem as the people in the center may be at the right distance while the ones at the ends maybe in the dark. Try turning on all the room lights that may be available, If that's not working then move your group outside if it's daylight or take several pictures of smaller groups of people.

Fill Flash

Fill flash works to supplement another lighting source. If you are shooting a person in a room with a large window in daylight the light from the window could go a long way to light up the room. However, your camera's exposure system may want to give preference to the light from the window in determining the amount of light to flash and you don't want that to happen. That way your subject's face will receive too

little light. You will need to be able to make manual settings or have setting overrides available on your camera to make the flash disregard the window light and only consider the light needed for the person's face.

The task of fill flash to bring balance between the two light sources, daylight and flash, in regard to intensity. When the two sources are not in balance at least one part of the picture will be either washed out or too black. A capable camera will be able to automatically produce only the needed amount of flash and for when you disagree with the automatic settings it will offer a wide range of manual settings.

For mixed lighting setups involving flash a light meter for flash will be very helpful and the top models can display combined exposure values of both flash and ambient light sources giving you your manual settings. A good model light meter for flash will cost well over $100. If you have the time you can improve your shot by setting up constant electric lighting that bounces light off a white surface rendering a more pleasant effect. Since the light is constant you will have more control over the exposure settings. This method may introduce color temperature issues depending on the exact type of lighting you choose.

Don't assume that the flash is only for indoors. There are many outside situations with sun and shadows that will benefit from flash and fill flash.

If your camera has a flash accessory mount, hot shoe, then you can shop around for a flash that meets your needs. An accessory flash will offer more options and more power that can light up larger rooms. With such flash units you may have the ability to mount the flash on a tripod with a connecting cable that allows the light from the flash to come from an angle other than the direction of the camera. Accessory flashes may also allow you to add the capability for bounced or diffuse light to render more pleasing effects.

Fill Flash with Back Lighting

If your subject is between you and the main light source, you have a "back lighting" situation. Fill flash can save your picture. The image below has visual appeal with or without fill flash so you might want to try it both ways.

Flash Considerations

The red-eye effect is a common problem with flash units that are located on the camera. Some countermeasures employed by camera manufacturers to counteract this effect don't work well and cause pictures of people blinking their eyes. Try having the subject look to the side of the camera or at some angle that avoids getting a reflection from the back of the eyes. A bounce flash will also fix this problem.

Most camera-based flashes yield harsh light which can lead to uncomplimentary shadows upon your subject's face. Consider bouncing the flash or adding existing light, both natural and artificial, to improve results.

There are public places where you are not allowed to use your flash or where shooting flash is not appropriate, Again, learn to be creative with the existing light. Also, remember that camera flash units are not a subtle light source and too many flash pictures will irritate some of your subjects. However, when your camera's auto shutter is indicating a shutter speed below 1/60th of a second then you likely need a flash or a tripod.

Be sure to set the shutter speed to sync with the flash unit and, whenever possible, do the shot first without flash and view the result. Such an image may clearly indicate where more light is needed and even how much more light is needed.

Depth-of-Field

This concept sometimes called "depth-of-focus". Your photo is two dimensional. Until 3-D technology progresses far beyond its current capabilities your picture will have height and width. That's all you get. Depth is a concept we impose when we view that a flat photo is a representation of a scene from the real world where true 3-D does exist.

Depth-of-focus is a range of distance within your picture, in terms of depth, that is in sharp focus. Say you have a picture of a person and they are in sharp focus. The flower in front of them if a bit fuzzy and the building behind them is also somewhat unclear. You have succeeded in placing your

subject within the range of sharp focus for the camera settings and light conditions at the time.

The ability to manipulate depth-of-focus is another tool you have to more strongly direct the viewer's attention to your intended subject. A busy background can threaten to overwhelm your subject as they blend with the scene. Intentionally narrowing the depth of focus in your shot can convert the busy background scene into a broad swath of color that highlights and enhances your subject while tending to push them forward from the din of color.

Manipulating the depth-of-focus is all about aperture settings on your lens. A large opening such as F-2.8 will yield a narrow depth-of-focus while a small aperture such as F-22 will give a very wide depth-of-focus. If you want everything in the picture from a few inches to infinity to be in focus, then use a small aperture.

Assuming your light source is not within your control, such as sunlight, then it is up to you to make all the right settings on the camera to get your desired result. You must think in terms of proper light exposure of your image. If you increase the aperture, which allows more light to enter the lens, you must also increase the shutter speed so that the exposure time is decreased. On a camera that provides manual settings you must be willing to practice and experiment. It's only a matter of recording your settings and checking out the results for those settings. How do the various settings affect exposure, depth of focus and

sharpness of the image? Consider your desired effect for each photo. That will lead to your priority setting, such as the aperture. In this case, your preference is to set the aperture where you need it to be and then set the right shutter speed to make a good exposure.

With some "automatic" cameras you may be able to increase the shutter speed to force the camera's light exposure logic to compensate by increasing the aperture to about what you need it to be. If you can do that then you can still manipulate depth-of-focus.

Image Composition

Learn the classic rules of image composition and learn how to use them. Then you can best decide when to break those rules to your advantage. In the long run you'll enjoy photography more when you learn to compose images that suit your own sense of the aesthetic. The act of capturing an image that demonstrates effective image composition is a lot like writing an entry in a book that's all about you. You decide what goes into the picture. In terms of focus, brightness and all the photographic elements under your control, you decide where it goes and why.

If part of your motivation is to convey a message to others, you'll want to learn the language of images. You'll also want to understand how images communicate to people. Images are composed through application of the 'elements of design'. Keep in mind what I say elsewhere in this book

about studying the works of the master painters. They knew image composition and how to make one picture speak volumes. In many cases they spent days and weeks completing one painting so they had to pack a lot of message into that one effort. What a different world that seems from shooting a picture in 1/1000th of a second.

Through your images you will attempt to engage 'the mind's eye' of your audience. The fact is your audience will be human and the human mind has some predictable and limiting ways to interact with images. Learn the details of that process and you'll know how to make pictures that communicate.

The good news is if you read some of the rules and then you review samples of the pictures that you've already taken you may discover that you were following the rules before you knew them. There's a good reason for that.

Selected Rules of Composition

a. If you have a portrait of a person and it appears they are looking out at something then give them some space in the picture to help indicate that fact. If you have a moving object in your picture give it some space to be moving into. That's the Rule of Space.

b. In your mind draw a tic-tac-toe board on the entire area of your picture. As a result, you have divided your picture into thirds with 3 columns across and 3 rows from top to bottom. Focus upon the lines. The mind prefers that you place your

main subject along one of those lines. Better yet place your subject where 2 lines intersect. That's the Rule of Thirds.

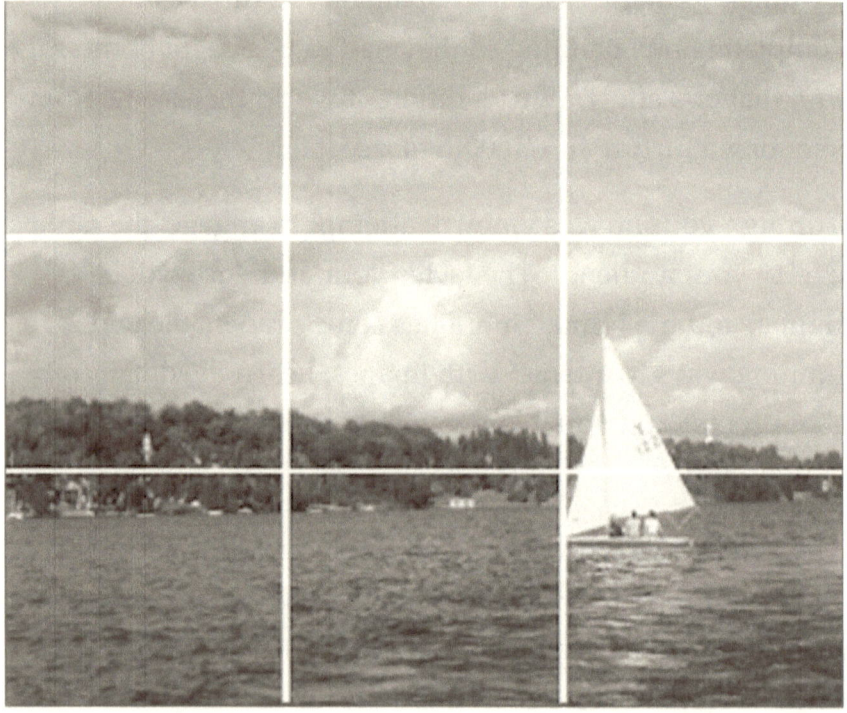

My sailboat picture does well by this rule by dividing the land and sky along the length of the bottom line. I came close to placing my main subject, the sailboat, at the intersection of two lines in the bottom right thirds. Also, regarding the Rule of Space, I gave my sailboat room to travel.

c. The human mind will allocate more focus toward an image that has one strong center of interest or that has 3

objects that work together to form a center of interest. Not 2 and not 4. That's the Rule of odds.

d. In most cases you will want to keep your images as uncluttered as possible. Why include unnecessary elements that only serve to detract from your subject?

e. Balancing Elements - in this case your main elements could be one large object to the left and two small objects to the right. All these elements are away from the image center. In a visual sense, when all objects are considered, they can be seen as balancing each other in a way that brings a higher sense of equilibrium to your image.

These are examples of the rules of composition. If you find that they help you take better pictures, you may want to research more about this subject.

Color Temperature

The appearance of a light source can be described as its color temperature, which is measured in degrees of Kelvin or K. Kelvin temperatures for residential lighting frequently fall between 2000K to 6500K. For a warm-white to yellow look in your pictures, you want a light source of about 3000K. A value near 4500K provides a cool-white cast. I say, think of a neutral white light with a blue tint. Then 5000K to 6500K lighting is said to mimic daylight. As daylight varies by time of day, I say think of this color temperature range as blue-white light.

Creativity from Within

Purpose and Process in Photography

As you improve your photography skill through experience you will also learn all the ways you can edit and enhance your results with photo editing. You'll be teaching yourself to take pictures in a way that considers their intended purpose. If you are new to photo editing, you'll find that there are a great variety of software titles available at prices that range from $0 to over a thousand dollars.

You can 'process' any image you have in your collection, but image editing is done best with great images. Once you're able take your creative photo editing talents into account while taking pictures you'll be connecting and merging the two processes into one powerful skill.

Motivation

Some of you will catch the photo bug which means that photography may lead to a life-long hobby or even a profession. If this becomes true for you, I suggest that you make the effort to do some research and find out about the people who made photography what it is today.

You can benefit from acquainting yourself to the accumulated knowledge and experiences of some of the great photographic artists that came before you. I expect your discoveries will be entertaining and educational as well as motivational. The significance of Alfred Stieglitz is that during his early career he had a chip on his shoulder because people were not taking photography seriously. Media such as sculpture and oil painting were 'art' and photography was considered to be something of a gimmick. Stieglitz promoted his photography tirelessly in the US and in Europe. Even though he had little money he was able to establish and continue operating a gallery for both traditional art and photography in New York City. This brought associations with many of the great creative minds of the time. Eventually he was successful, and he is credited for raising photography to the level of an art in the public perception.

Ansel Adams is most remembered for his black and white photographs. He became a recognized public figure for both his photography and his environmentalism. Adams did know about color film and worked in that medium as well. I believe you will share in the appreciation of artistic achievement as revealed in his work.

In addition to being a great photographer Andreas Feininger wrote manuals about photography that remain relevant today. For example, when I write about the importance of defining subject matter – that is Feininger. Any photographer could also benefit from what Feininger has to say about topics such as composing your image, lighting and focus.

Roles of Photography

Photography is one of the most popular hobbies mentioned in people's personal profiles on Twitter, Facebook and other online social media sites. You can easily discover the great variety of ways people enjoy photography. In many cases photography comes at the end of the list. Not forgotten but more of an add-on to other favorite activities.

A common example could be "I enjoy my children, other people, the outdoors, travel, sports and photography." This entry suggests the broad supporting role photography plays for this person. Photography is an extremely versatile hobby and can play a central or supporting role with your other interests. A lot of pictures are taken on vacation trips.

Photography for Family and Fun

Taking holiday snapshots for the family may include a detailed list of considerations such as getting everyone in the shot, making sure everyone is attentive and smiling and finally making sure everyone gets a copy of the picture. It all amounts to making sure your audience is satisfied.

Most holidays are considered a time for feasting so food is often featured in holiday photos. Presenting food items for the advertising industry is a very specialized and technical area of photography. The process sometimes involves a certain amount of 'retouching'. It's not that the food isn't great. It's just that conveying the best qualities of food items through a photograph is very tricky. So, it's all about composition, color elements and trying to identify some center of interest. At Thanksgiving the center of interest for most people is the bird but others may choose the mashed potatoes.

Tasty Subjects:

a. Food items need the same lighting considerations as any other subject. Don't forget to take advantage of a nearby window to supplement your lighting.

b. If you are featuring just one item such as a desert then leave out the other food items but include a fork or part of a cup of coffee to balance the composition and add interest.

c. Professional photographers will apply vegetable oil to some food items to make them glisten. I don't recommend doing that to Aunt Kathy's baked ham at Christmas dinner.

d. Make a shot where you get down to the level of the food. Try a macro shot to capture texture and to make small details noticeable.

e. Plan ahead so you can shoot those steaming hot items while they are still steaming and before things settle too much.

f. Most chefs would consider it a compliment if you were motivated to document their culinary feats as they arrive at your table in a fine restaurant. A lot of people do this while on vacation.

Family Events

I don't envy wedding photographers one bit. They have a tough job. Yet the task of snapping photos of an important event does not preclude being creative and having fun with the process. Your family is one audience you don't want to hear back from about how you messed up the holiday pictures. After all they're relying on you to record the event and to provide them with copies of the photos. Sure, everyone may be 'taking pictures' but you are the photographer. Good luck with this kind of assignment.

There is a more specific way to view photography that is exclusively about what you want to do with the hobby and choosing your target audience and your message.

Personal Expression and Creative Photography

For me photography is most enjoyable when I'm using the medium as an expression of my artistic and creative urges. I'm shooting what I choose and experimenting and learning. Also, I am anticipating sharing my favorite results with my

audience. I may also anticipate sharing my experiments, successful or failed, with other photographers who will appreciate them.

If you can tolerate criticism of your favorite photographic work you may be ready for peer-to-peer review of your work, including your experiments. I have a popular web site to recommend to all creative minds including photographers. For those who are not familiar with Zoetrope.com I suggest you give this web site a visit. The central benefit for photographers at this site is the ability to get peer reviews for your work. You must review a number of photographs by others for each photograph of your own that you submit.

Communicating through Photography

Not all the methods for improving your photography skills involve using a gadget or working with software tools. Some of the most important methods are in your mind. Beyond the mechanics of setting a shutter speed or transferring a file is the power to communicate.

When taking a photo learn to ask yourself questions such as:

a. What mood am I trying to convey?

b. Am I trying to make a journalistic point?

c. Does this composition communicate to my intended audience?

d. Does my composition have the capacity to capture interest out of a casual glance?

e. Does my composition lead the eye (or the mind's eye) to a place where I can engage the viewer?

f. Will my composition repel the viewer and short circuit my effort to make a visual impression?

g. Am I including all the picture elements necessary for the viewer to understand what the picture is about?

h. Is my photo entertaining, informative or humorous?

These are my examples of questions that you can devise to help you take pictures that are more interesting and that communicate your message.

Convey a Message

Of course, it's not only about recording the view as you see it. It's a lot about communicating the feeling of being part of that scene. It's about saying, "I feel a connection to this place and time. I want to preserve it and share it with others." When you really get excited about a particular landscape you want to preserve the mood, feeling or message of the place and to share the associated state of mind with other people.

Experiment with exposure. Try several practice shots to see how accurate your camera and your judgment are in terms of the results you expected. Don't be overwhelmed when

you're having difficulty trying to capture the entire view in one shot. Your shot may contain several smaller scenes that deserve individual attention. Each element of the larger landscape can be composed as a great image which conveys its own strong message.

A photo intended as social commentary is another way to send a message to your viewers. Make sure that all the elements are present in the image that are needed for your viewers to understand your message. For example, you may be documenting picketers promoting awareness of low wages at a store chain. In this case your ideal single shot would include depiction of the picketer as an individual person with a concern, enough of the picket sign to show their message and the store and its name should be visible in the background. Of course, you don't give up if you can't grab the ideal shot. You gladly settle for two or more shots that do convey the message.

The Language of Creativity

Quick Photo Tips

How do you make rich streaming waterfalls that look great?

Pictures that present full streaming waterfalls are the result of a longer shutter speed. You'll get better results if you use a tripod. In full daylight try a shutter speed of about 1 second and check the results. If the streaming effect is not sufficiently pronounced, then go for 2 seconds. In low light situations the shutter speed could be 3 seconds and the aperture setting may be quite wide so monitor depth-of-focus.

How do I shoot fireworks?

Let's assume it is dark at the time. A tripod could improve results along with a remote shutter release. Turn off the flash and any auto focus mode on your camera. Point the camera in the general direction where you expect the fireworks to appear. Use the "B" for "bulb" setting on your shutter. With this setting the shutter will stay open for as long as you keep the shutter button pressed. Set a medium aperture around F 8 or F 5.6. If you don't have a bulb setting, try 2 seconds on

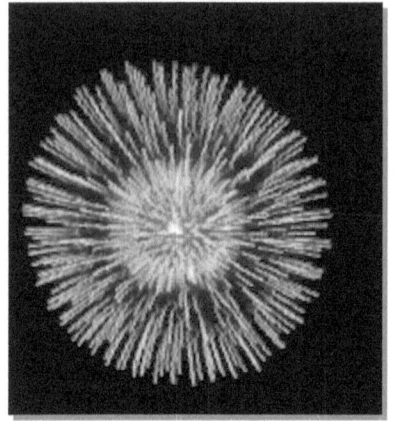

the shutter. You should be able to see the rocket rising up before the explosion, so you know it's time to push and hold the shutter button. When the brightness begins to fade release the shutter. Advance the film or leave it if you want to try multiple exposure blasts.

This composite of bursts was made by photo editing 4 shots into 1. If you are using a locking remote release don't leave the shutter open after the shot. It may look dark but twilight, headlights and other light sources that you don't normally notice will have a cumulative effect and will bring unwanted light patterns onto your shot.

How do I keep my camera lens clean?

It is important to keep your camera lens clean and clear. However, don't clean it until you see dirt or smudges that make the job necessary. Cleaning too often when not actually needed will wear down the lens coating and introduce the possibility of scratches for no reason. Also don't forget the idea of keeping a UV or skylight filter on all

the time. That move could greatly lessen the need for cleaning the lens. When it's time to clean your camera lens then take a moment to do it right. Photographic lens cleaning supplies are available at Wal-Mart, Amazon.com and most similar stores. Used sparingly lens cleaning fluid will help you remove dirt without scratching the lens. Lens cleaning tissues and cloths will also do fine without the fluid as long as you don't rub too hard.

Landscape Orientation vs. Portrait

One of the most common tendencies of new photographers that I've noticed is shooting everything in landscape orientation. At some point they'll discover that some pictures look better if you turn the camera on its side and shoot that way. Which leads to the second most common tendency: too many portrait shots. So eventually you'll learn how to decide which orientation is best for a particular shot and when it's best to shoot one of each and choose your preference later. Landscape vs. Portrait doesn't always seem like such a big deal. But to a new photographer it's like getting a second camera for free.

Tips for Portraits

If you aren't satisfied with your portraits of people there may an easy fix. Some people may tend to tense up when being photographed which causes them to look stiff and uncomfortable, have tight lips or extra wrinkles on their forehead. Learn to approach the photo session in a way that

sets a tone of calm and unobtrusive ease. Talk with your subject for a while prior to the shot maybe while suggesting a more comfortable pose. Remind yourself that you have a goal to convey the person's personality as well as their physical appearance. With that in mind don't insist that they always look into the camera for the shot. Let them chat with someone who is off camera or give them a meaningful prop to hold and to interact with. Remember what we've discussed elsewhere about introducing people's hobbies or pets into the session.

About Gadgets

Don't fall into the trap of believing that gathering more expensive and technically advanced photographic equipment will make you a better photographer.

When I first discovered photography I devoted a lot of effort to becoming familiar with and geeky about the latest photographic hardware. I was fortunate to come upon some writing by a famous and pioneering professional photographer early in my hobby development. His ideas shot the air out of my fantasies about expensive equipment which caused me to set aside the photo catalogues and glitzy magazines and to focus more upon the core principles of photography.

I read it several years ago so I don't have the full exact quote, but it was Andreas Feininger who said that a talented photographer can take great pictures with only a cardboard box and a pin hole. He expanded that idea by saying that good photography is, ". . . nothing but a matter of seeing, and thinking, and interest".

Photographing Buildings

People photograph buildings for reasons such as architectural studies, historical preservation and real estate sales. For a comprehensive study you may want to break down your subject into tasks such as interior, exterior, setting, architectural design and detail.

Interior shots include consideration of woodwork, halls, lighting fixtures, fireplaces and any significant details or unique features you may discover. Highlight the defining features of the interior design style. The exterior shots will

present the outside building appearance including the layout of windows, entrances and roof lines. Check for a porch, sunroom, lanai, and outside entertainment areas. Especially for homes, emphasize the lines and features that define the style such as Victorian, Mediterranean, Colonial or Tuscan. When considering the setting you may include neighboring buildings, the lawn, pool, garden, tennis court and shots from the street.

You may be luckier with your building shot and not have to deal with electrical lines that hurt the shot. With exterior shots of tall buildings, such as office buildings and churches, you'll likely experience problems with perspective in your shots as lines converge toward the top giving an odd and unnatural appearance. If you are serious about this type of

shot, you'll want a tilt-shift lens to correct the perspective problems. The most interesting part of building photography is capturing details that people pass by every day but don't notice. Examples of details are gargoyles, brick design and fancy trim.

Selected Photographic Terms

This section is a brief outline of basic photographic terms plus descriptions of some of the electronic and mechanical systems in your camera and how to make them work for you.

Aperture - Think of aperture as the function that controls the volume of light allowed through the lens. At full aperture your camera lens is 'wide-open' and allowing the full volume of light to enter. To reduce the aperture the lens has a circle of thin metal tabs that can enter the light stream and form a smaller hole for light to pass through.

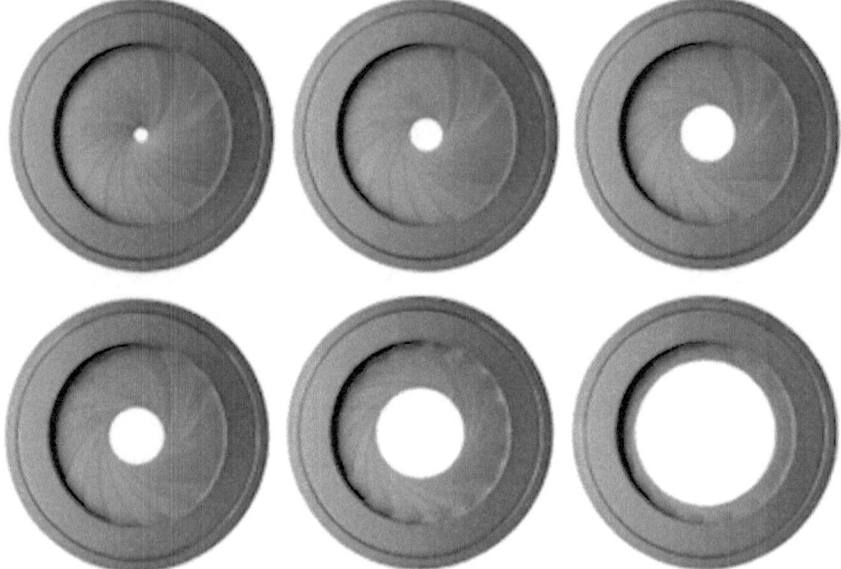

B-roll – In videography, the B-roll contains supplemental or alternative footage. Even a single-person YouTube operation can provide B-roll by setting up a second camera to run continuously from one viewpoint while the main camera is doing cuts, pans and following the action. During the editing process portions of the B-roll can be used to cut away from the main camera as if there was a two-camera setup.

Bokeh - The aesthetic quality of the blur in the out-of-focus parts of an image as produced by a lens.

Bracketing – Refers to taking additional pictures of the subject through a range of exposures both lighter and darker. This technique gives you a better chance of getting exactly the results you were seeking.

Contrast - The range of values in the light to dark areas of the image. An image is considered to have excessive contrast if it contains too few tones over a wide range as compared to the original scene. You need the right amount of contrast to see the image. Beyond that there can be too much difference between the light and dark areas.

Exposure System - The exposure system coordinates the lens aperture and the shutter speed to adjust to various lighting conditions. An electronic sensor reads the light levels in your scene and the exposure system makes the needed adjustments.

F-Stop - A measure of the lens aperture. A lens will be able to apply any F-Stop from a range of possibilities according to the lens design. The numbers indicate lens openings from wide open to fully stopped down. Remember that the larger the number the smaller the lens opening. A lens rated at a maximum aperture of F-1.8 is wide-open when set to that F-Stop. The same lens set at F-Stop 22 might be fully "stopped down" and is allowing the minimum amount of light to pass.

Film Speed - In film cameras the speed of the film you load into the camera determines how much light is needed to make a good exposure. The ISO number on the film packaging tells you the film's speed and it can't be changed. A higher number film such as ISO 400 is a 'fast' film and ISO 100 is a slower film. The concept is brought forward to digital cameras through the film speed equivalent. The speed can be selected manually or automatically according

to the light conditions and current settings on the camera. Notice that in both film and digital cameras faster speed settings bring grainer images and reduced image quality.

Filter - An example of a photographic lens filter is a glass disk that screws into threads that are located at the very front part of your camera's lens. Common types of lens filters are Polaroid filters, skylight filters, UV Filters, starburst effect filters and filters of various colors. Some lens filters can be left in place to protect the topmost exposed surface of the camera lens from being scratched.

Flash - The flash is a small electronic device that can be built into the camera body or that can attach to your camera. A flash provides a burst of light that is synchronized with your exposure system to produce the amount light needed to make sharp photos indoors or in any low light situation.

Frame Rate - For video, framerate is the number of individual frames or images that are displayed per second or Frames Per Second. We'll look briefly at 3 possible framerates for your videos: 24, 30 and 60 in approximate numbers. 24 fps is the minimum you should consider for general video work. This setting will likely show shaking, jittering or stuttering during faster action and pan scenes. I think most videographers would recommend 30 fps as a framerate that will serve best in most situations. 60 fps is a great choice for continuous fast action. For me, the best thing about 60 fps is that it can be slowed to 30 fps in editing to yield a good quality video in slow motion.

Framing - The edges of your photo frame the view of your shot. But within the scene you can add a framing effect that tends to emphasize your subject and create additional focus upon the section you want the viewer to consider most. Frames within a shot can be created by objects such as windows, two large trees or a doorway in the foreground. This technique guides the viewer to the intended center of interest for your photo and adds depth to the scene.

Image sensor - is the electronic device that sits behind the focal plane shutter on DSLR cameras. Examples of image sensor types are CMOS and CCD. This device works to capture the image and performs a function similar to that of film in a film camera. Information from the image sensor is saved to memory as your image file.

Lens Coating - Coatings are applied to photographic lenses to afford protection and to improve the photographic properties of the lens. Non-glare coatings are a common example. You can see the coating on the top element of high-quality lenses.

Lens System - The essence of a lens system is the glass lens that focuses light. Since the lens is the best place to intercept light entering the camera the lens 'system' may also include parts that alter aperture, a shutter or filters that render special effects. Lens system also refers to the fact that many cameras have lenses that are actually composed of individual lenses called elements. Each lens element functions in a unique way to improve the quality of the light

that makes your pictures. A lens system can also add capabilities such as macro or zoom functions.

Mirrorless Camera - A digital camera that accepts different types of lenses. Mirrorless cameras do not use a mirror to reflect the image into the viewfinder. This design makes them smaller and lighter in weight than a DSLR but can negatively affect low-light performance.

Rangefinder - This is a popular camera body type that features a lens for taking the picture and a separate viewfinder mechanism through which you compose your shot. The viewfinder may feature parallax correction to help compensate for the different angles of view between the viewfinder and the photographic lens. This body type can be found in common point-and-shoot cameras all the way up to expensive professional camera models.

Shutter - The shutter is the part of the camera that controls the length of time that light is permitted to 'expose' the place in your camera where the image is recorded. The shutter can be thought of as part of the exposure system. The two most common types of camera shutter are leaf shutters, found in rangefinder body types, and focal plane shutters which are found in SLR camera body designs.

SLR/DSLR Camera - Single Lens Reflex is a camera body type that offers many advantages over the standard fixed lens camera. With an SLR the lens that you use to focus and compose your shot is the same high-quality lens that will

take the picture. The SLR design works well with through-the-lens exposure systems and also accommodates a variety of interchangeable lenses for wide angle or zoom shots.

Tripod - The tripod is an accessory that holds the camera steady on a small elevated platform for long exposure times or to steady long telephoto lenses. With the help of a shutter timer a tripod can also allow you to join the picture. Many cameras have threading on their undersides to accommodate the attachment of a tripod.

Mood Enhancers

The possibilities are endless when you think in terms of adding elements such as weather, season or twilight to your photos. They may not always be the main point of the shot, but they immediately set a mood. Elements such as fog, rain, snow and an unusually colorful sky can make a great landscape shot even better.

Sunsets - and sunrises have never gone out of style so enjoy satisfying your urge to shoot them. Many landscape scenes can be enhanced by shooting them at sunrise or sunset. Protect your eyes at all times. Be careful not to damage your camera and never shoot the sun unless it is at the horizon. In terms of dramatic lighting the hour after sunrise and the hour before sunset can be thought of as golden hours.

The Moon - Putting the moon in your shoot is sometimes possible. You'll notice that the moon doesn't show up as large in the photo as it appeared to you at the time of the shot. You could try to address that problem with a telephoto lens.

Seasonal Clues - When you can add elements such as autumn foliage, spring blossoms, summer grass or snow

they will add interest to your landscapes and will help to tell the story.

Rain - In light overcast with rain that's not so heavy as to block the view, you can grab a great mood shot and your picture will benefit from the even lighting. Don't worry about capturing the falling rain in your image. It will have to be closer to a downpour to show results. Rather look for evidence of rain such as drops of water falling from a leaf or a puddle to include in your shot. For rainy cityscapes look for light reflected from the wet street and people carrying umbrellas.

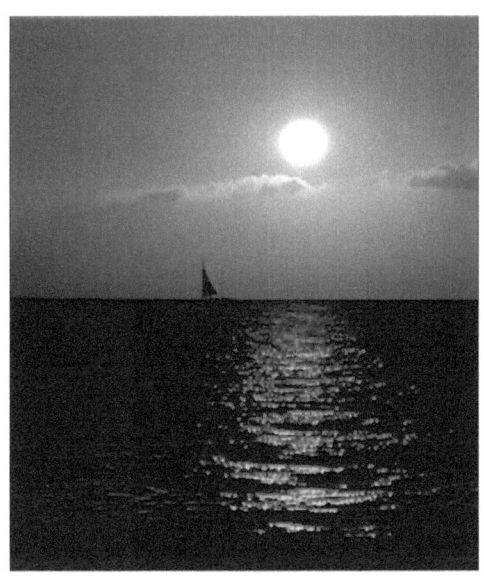

Fog - You could make a composition with a person or object in the foreground and the fog in the background or you could use large objects such as a bridge or office building wrapped in fog at a moderate distance. The easiest way to capture fog is to make a composition which includes a patch of fog at distance while you stand in the clear.

Water Features - Including a pond, river, lake, fountain or ocean in your scene is a great way to tie into my 'mood

enhancers' concept. Such water features tend to highlight the great differences as well as the higher-level integration between the worlds of land and water. Also, water features offer the opportunity to catch a reflection of land-based objects upon the nearby water.

The Tools of Creativity

Cameras

We buy a camera to take pictures. The amount of money we spend depends on how we plan to use our new camera and how much money we can afford to spend.

One thing is certain. When people see us carrying a camera, they assume we plan to take pictures.

We can buy a camera for $20 or we can spend many thousands of dollars. There are action cameras, security cameras, disposable cameras, instant cameras, 360 cameras and so forth. The main point I'd like to make for this introduction is about cameras vs smartphones with cameras. If our camera and camera gear are a lot of trouble to haul around, and we didn't bother to bring them along, we won't be taking any pictures. In truth, we seldom find ourselves without a way to take pictures because most of us faithfully carry our smartphones everywhere.

Smartphones

We use smartphones for voice communication, for texts, for maps, to play games and for all the apps they hold. And you can guess there's another feature I'm going to talk about.

They have a camera. Smartphone cameras have become very capable image tools.

I just checked out the iPhone Xs for its Dual 12MP rear camera features. Apple says this is a "Breakthrough dual-camera system." And that "The world's most popular camera is defining a new era of photography."

I'm glad they take photography so seriously. I read on about this dual-camera system with advanced algorithms that claims to unlock new creative possibilities and help you capture incredible photos.

The camera in the iPhone Xs does HDR, has fast sensors, adjustable depth of field, takes great portraits and yields sophisticated bokeh. According to Apple, this phone provides low-light detail, sharper action shots and does 4K video. This may raise a question for some people. "Why do I even need a dedicated camera?"

Smartphone Photography

Some folks never use their smartphone's camera. However, most people use their smartphone's camera either exclusively or in addition to their *regular* camera. Regardless of the brand or style, the fact that you have your smartphone near you most of the time means that you also have a camera with you most of the time.

As evidenced by the iPhone Xs description above, the quality of phone cameras is improving rapidly. Cameras in the 12 to 21-megapixel neighborhood are becoming popular. Overall smartphone functionality is improving as well. There are many apps for you to install that increase the ability of the device to take great photos, edit them and then share them socially.

As more people become aware of the photographic abilities of the modern smartphone or tablet, cameras on mobile devices are used more and more by both amateur and professional photographers.

During events such as Flight 1549's *Miracle on the Hudson*, the devastation of Superstorm Sandy on the Eastern Seaboard or social upheaval around the world, the pictures that we saw first and remember most were provided by

people. They are *citizen journalists* or *street journalists* who use their smartphone cameras to tell a story with light.

With their ability to share images, video and stories immediately to blogs and social media, smartphones and other mobile devices are at the cutting edge in the media revolution.

Photo Editing Apps

Smartphone apps are constantly being updated and old favorites are replaced by hot new titles. Your best bet is to explore online for available Android and iOS photo apps. Reading the user reviews should also be very helpful when selecting photo apps.

The main point to remember is that both smartphone photography and traditional camera photography are ways to tell your story with light. There may be some special considerations but the old rules regarding picture composition, focal points, focus, exposure and more still apply.

Example Photography Apps (Android and/or iOS)

Adobe Lightroom – A popular photography app for Android and iOS. Lightroom is a full-featured photo manager and editor, complete with RAW photo support, presets, exposure adjustments and watermarking. Make advanced edits to color, exposure, tone, and contrast.

VSCO – An Android app provides presets for shooting and editing photos. Has film-inspired presets, and advanced camera controls. Publish images or curate others to your VSCO profile.

There are many others such as Snapseed (iOS and Android) and Prisma Photo Editor (iOS and Android).

Some Smartphone Photography Tips

Smartphones Use LED Flash - Most smartphone flashes function like LED flashlights. For some models, color temperature may not be accurate, or they may not produce a light that's bright enough for video or to capture movement. There are brackets that allow you to add an additional LED light source. Also consider existing light as a way to augment your indoor lighting.

Avoid Using the Zoom Function – On a smartphone the zoom function simply enlarges the size of a portion of your image using the same amount of picture information that made the original scene. By using the zoom function, you are telling your camera to make a poor-quality enlargement of one section of your original. **You can buy optical zoom attachments for your smartphone.** Otherwise, your best option is to resize or crop your original photo images in photo editing software.

Smartphone Lens Care - Your smartphone is a multipurpose device that gets a lot of use. Be aware that the lens on your smartphone may be seriously smudged. Your

phone endures all kinds of weather and sits in your pocket or purse most of the time for weeks. Stores carry disposable wipes for use on your phone.

Get Close to Your Subject - One of the most common mistakes people make with phone camera shots is standing too far from the subject. Their subject ends up being a tiny, unrecognizable object in the distance. Camera phone images tend to be small so fill up your viewfinder with your main subject.

Move Slowly and Keep Steady - Be as still as you can when you press the shutter button to get the sharpest image or video possible. Smartphone are light in weight, and they have an odd shape. Some phone cameras may have an unusually long lag time between when you press the button and when the picture is taken.

People Pictures - As with all photography, when taking portraits make sure your background is as uncluttered as possible. With a cell phone it will be very difficult to throw the background out of focus using a shallow depth-of-field.

Purchase A Class 10 SD Card – Get one with at least 32 GB or 64 GB capacity. Check your smartphone's manual for possible maximum limits to capacity. With a high capacity SD card, you can take many more pictures on one run. You can also use larger size and higher quality settings per your smartphone's capability. A Class 10 SD Card is good for photography and transfers data at 10 Mb/s.

Working with Smartphone Picture Files – To transfer photos and videos from your phone to your PC, connect your phone to the PC with a USB cable. Make sure the phone is on and unlocked, and that you're using a working cable.

You can share your photos on social media or even do a live feed video on YouTube.

You can also backup your photos to a cloud-based storage service.

If You have An Older Device, You May Still Have Options - Try emailing the photos to your email address as an attachment to a message. This may not work due to the limitations of your device or the mobile service.

Buy a memory card for your cell phone. Check to see if your device takes a memory card and what kind is required. Many cell phones use a microSD Memory Card up to a capacity of 32GB or 64GB. MicroSD cards often include a converter that will allow your microSD card to fit in a regular SD card slot such as the one in most laptops. Also, your PC may have a card reader, or you can buy and external car reader for your PC or Laptop for under $15.

Camera Body Types

Camera body type refers to the physical design of the camera which largely determines the capabilities of the camera. Each body style carries with it a list of advantages and disadvantages. Knowing these factors will help you match your camera selection to your interests in photography.

Shopping for a Camera, Small but Useful Features:

a. Threading on the inside of the exposure push button so that you can use a remote or locking shutter release.

b. Threading under the camera body so you can use it with a tripod.

c. Electronic time delay on exposure so that you can get into the picture.

d. For Rangefinder and SLR types – Flash hot shoe so that you can purchase a separate flash unit, even a different brand of flash than the camera body. For point-and-shoot models the flash is usually built in.

e. Look for threading on the inside end of the lens barrel away from the body, just above the lens glass, so you can use photographic filters.

f. Look for grooves on the sides of the viewfinder. Some people like to add a light and glare protector cup to the viewfinder. Those grooves are where it will fit.

Point-and-Shoot Cameras

Point-and-shoot is the best thing to happen to popular photography. You may appreciate the fine images that a high-end SLR or rangefinder can produce, but, what good is that if you don't bother to take your camera with you because it's too bulky with all those accessories or just plain too expensive to risk damage or loss.

The point-and-shoot camera can be there when you need it and that means a lot. Also, according to their name, the whole process of picture taking can be accomplished more quickly and smoothly.

Rangefinder Cameras

You view, compose and focus the image through a separate viewfinder while the film is exposed through the primary lens. This design includes the more common point-and-shoot (Compact) cameras. Parallax considerations arise because you are composing the shot at a different angle than the primary lens sees. Parallax correction works well until you move in very close to the subject.

In most serious 35 mm film and digital rangefinder cameras the viewfinder gives you a good rendition of what the main lens is going to record. Focus is determined in the

viewfinder. Some through-the-Lens (TTL – Metering for the exposure system) versions will match Single Lens Reflex (SLR) cameras in automatic exposure accuracy.

Other than the common Point-and-Shoot Models the availability of this design is limited and prices for the most classic rangefinder camera models have risen toward the stratosphere. Most of the classic designs are reserved for high-end cameras priced over $2,000. Some good examples of high-end brand names of modern rangefinder designs are Leica, Contac, Konica, and Hasselblad.

High-end rangefinders have an array of accessories and a capability for lens interchangeability approaching that of SLR body designs.

DSLR Cameras

The DSLR body design is one of the most basic and powerful advances in modern photography. You compose the picture, measure for proper light exposure, and set the focus by the same high-quality primary lens through which the light will pass that produces the final image. This design also makes adjusting your wide-angle, telephoto, macro lenses and filter settings as easy as looking through the viewfinder.

When you look through the viewfinder you are seeing the view through the primary lens. Light travels from a lower mirror up through a prism and then on through the

viewfinder to your eyes. The image is corrected for orientation, so you see the image right side up.

When you press the shutter release to shoot the picture the lower mirror must rise out of the way while a focal plane shutter travels across the body behind the lens and exposes a slit of light that becomes the whole picture in one pass. These factors make for a slightly noisier exposure than other body types. However, DSLR cameras can be just as reliable as other types while the noise factor is minimal.

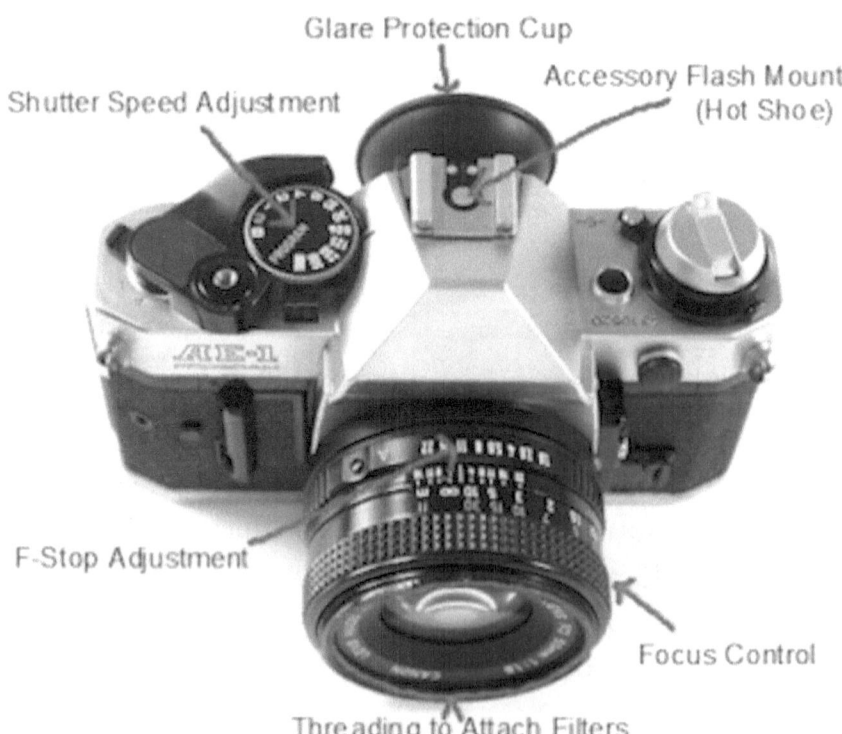

Mirrorless Cameras

Mirrorless cameras are usually lighter and smaller than a DSLR camera. They also operate quieter than a DSLR.

As the mirrorless camera has no mirror, you're directly viewing light from your image as it passes through the sensor. When you use a mirrorless camera you are actually looking at a small video screen instead of an optical viewfinder.

A point-and-shoot is a mirrorless camera is also a mirrorless camera. Most cameras marketed a mirrorless feature a quality design similar to DSLR standards and taking a range of interchangeable lenses.

Photographic Lenses

Lens types described here primarily refer to lenses for Single Lens Reflex (SLR) Cameras or Mirrorless Cameras. This type of camera utilizes interchangeable lenses. SLR cameras also enable image composing, exposure measurement and focusing through the same lens that will be taking the actual photograph.

SLR cameras make the use of Macro, Telephoto, Wide Angle and Zoom lenses much more feasible. They take out much of the guesswork and increase opportunities for you to achieve your creative and journalistic goals.

There are SLR lenses available for almost any photographic need you can imagine. The types listed below represent the most common and widely available. SLR cameras are sold as the camera body only, the camera with a normal lens or the camera with a zoom lens whose range usually includes the range of a normal lens. These are the most common starting configurations.

An SLR lens is not one lens. The actual lens barrel contains 5 or 6 or more "elements" which are organized into "groups". Each element would qualify as a lens. So the SLR lens is actually a system of lenses that produce high quality images.

Normal Lens

The normal lens is often the one that comes with your camera when it is new. For SLR and Mirrorless photography a normal lens will commonly be in the range of 50mm to 55mm. In all cases the normal lens is intended to be one that gives your pictures the perspective that you see with your unaided eyes.

Telephoto Lens

Telephoto lenses will give an effect as if you walked up to a section of the scene you are shooting. However, the effect on your image is not the same. Background objects such as clouds, hills, or buildings will appear disproportionately large in relation to a subject that is in the foreground. The effect is unmistakable. The intentional use of this effect can produce dramatic results such as when you put a rising moon prominently into the background.

For consumer DSLR and mirrorless photography telephoto lenses begin at 85mm and go up to 2000mm or more. Again, considering the format, a 50mm lens will magnify about 1:1 or no magnification. A 200mm will magnify about 4X or four times the 50mm normal lens perspective. It seems you can divide by 50 to get the "X" approximate magnification value of a telephoto lens.

More on Telephoto Lenses

a. A telephoto at about 100mm will yield superior portrait photos.

b. "Long" telephoto lenses, say 200mm and over, will yield best results when you are able to use a tripod to reduce vibration. Any telephoto lens magnifies shaking or other movement of the camera.

c. A telephoto lens will magnify haze in the atmosphere. In many situations outdoors a telephoto will do best with a haze reduction filter added.

Wide-Angle Lens

A wide-angle lens is well suited to landscape photography. Serious landscape photography requires mastering the use of wide-angle lenses. For most of us one good wide-angle zoom can handle many situations while reducing equipment costs. When you want to capture the big picture including a sky full of clouds, a wide-angle lens can put a lot in one image. There will be times when a tripod comes in handy also.

To be considered wide-angle a lens should have a focal length less than that of the normal lens. Wide angles lenses will give you a perspective as if you backed up some distance to get more of the scene into your picture. For SLR and Mirrorless cameras they begin below 45mm. You will find that a 35mm lens gives a sufficiently wide perspective

for most shots. A 28 mm, although popular, is past the threshold of noticeable distortion and is too drastic for some purposes.

More on Wide Angle Lenses

When photographing groups of people with a wide-angle lens, you'll be making people at the edges look wider and heavier than they truly are. That's why you probably don't want to use a 28mm wide-angle lens when a 35mm lens will fit everyone into the picture.

Experiment with cloud effects in a wide-angle lens. You'll enjoy the dramatic results.

The Nikon AF-S DX NIKKOR 35mm f/1.8G lens

My selected example for a wide-angle lens is the Nikon AF-S DX NIKKOR 35mm f/1.8G lens. This lens is a great first add-on for Nikon kit lens owners

This Nikon AF-S DX NIKKOR 35mm lens is an excellent choice after you've been using the kit lenses for a while. It's fast 1.8 lens is a welcome improvement and the quick locking auto focus system is amazing when compared to the kit zoom lenses.

It's important to understand that this lens' 35mm focal length is effectively a 50mm lens in the Nikon FX format. For DX camera owners, this lens provides a view similar to what

the unaided human eye perceives. It's a normal, standard lens.

The aspherical element minimizes coma and other lens aberrations, improving image quality. The Super Integrated Coating (SIC) makes excellent light transmission efficiency possible and assures true color consistency. The Silent Wave Motor (SWM) enables fast, accurate and quiet autofocusing.

Macro Lens

This is the lens that produces those great close ups of flower blooms and bugs. With a macro you can place the front element of your camera lens just a few millimeters from the subject. The effect opens whole new worlds for photography.

More on Macro Lenses

a. You can purchase a normal or zoom lens that has macro functionality.

b. The biggest issue with this type of lens is "depth of focus". Focus on a point of interest and notice that other points merely millimeters away are already thrown out of focus. If you are photographing a butterfly with a macro you will have an impossible task trying to have the entire bug in focus.

c. To succeed with a macro lens you'll need a lot of light or fill flash or you'll have to back off a bit.

d. Both natural and flash lighting are issues with a macro. Successfully using a flash with a macro is a real talent.

Zoom Lenses

The zoom lens is a way to get multiple lens types in one unit. A particular zoom can operate within the wide-angle range (Such as 17 – 40mm). Another zoom might operate through the normal lens range and up to 200mm. There are zooms can that operate within the long telephoto range (100 – 400mm for example). Zooms can also include macro functionality.

If you are off on an expensive and far away vacation and can only take one lens consider taking a zoom that includes near normal in its range and up to about 200mm. Be sure that your zoom lens transitions smoothly through its range and that it doesn't require you to take your attention away from the view finder.

More on Zoom Lenses

a. An affordable zoom lens will be rated as a "slow" lens (f/3.5 or higher is common). They often require higher lighting levels.

b. A zoom lens has a higher element count and more mechanical functions than other lens types. Therefore, quality workmanship is required to achieve good results. That usually means higher cost.

Optical Zoom vs. Digital Zoom

There are two types of zoom function available on most cameras sold today:

Optical Zoom - refers to increasing the zoom lens power through settings on the lens which change the physical optical system in a way to make a portion of the scene look closer through optical magnification in the classic dictionary sense.

Digital zoom - Some claim that digital zoom is nothing more than a marketing ploy. Digital zoom is achieved through software within the camera that enlarges a portion of the original image in a way that is like the way photo editing software can enlarge a picture. Digital zoom may have its uses, but optical zoom is true zoom and not merely software manipulation that results in less original image information.

More Lens Types

Fisheye Lens - An ultra-wide lens for extreme panoramic landscapes and cityscapes.

360 Lens - This type is usually a dedicated camera that shoots only 360-degree scenes.

Tilt-shift Lens - A lens that can shift focus and correct for distortion. Used for photographing tall building to remove parallax. A Tilt–shift lens rotates the lens plane relative to the image plane (Tilt) and moves the lens parallel to the image plane (Shift).

Selected Photographic Equipment

Sliders

Camera Sliders for Video

A slider looks like a one to three-foot rail that allows your camera to "slide" from one end to the other. A slider should be well-constructed and must provide a solid base for your camera. I own and use a Rat Rig 14" Single Rail V-Slider. This model is the only slider I have first-hand experience using. So, I'll be writing about using my Rat Rig in detail.

Other examples of camera sliders include Revo Camera Track Slider V2 with Adjustable Feet, ikan Carbon Fiber Camera Slider with 19mm Track Rails, edelkrone SliderPLUS Long and the Manfrotto Camera Slider 60cm. There are many great sliders to choose from and, as always, I recommend you shop around for what works best for your needs.

I'm listing the slider options above because, from here on, I'll be writing exclusively about the only slider with which I have direct experience. I use the Rat Rig 14" Single Rail V-Slider. I didn't purchase feet with my slider. That was a mistake because I'm at the mercy of inexpensive tripods that can't support the camera weight at the ends of the slider.

Sliders have two main types of motion. When the camera points away from the slider at 90 degrees you get a smooth pan effect. When you point the camera to run along the rail you get a zoom toward or away from your subject. Both effects add a professional look to your videos.

My Rat Rig 14" Single Rail V-Slider is an affordable way to achieve creative photography. This Rat Rig V-Slider features movement based on 8 high quality bearings. No sticky friction-based movement here. The Delrin wheels provide a super smooth glide and a huge load capacity. This Slider uses only stainless steel and anodized aluminum, no plastic. With a solid tripod, this 14" Single Rail V-Slider brings smooth, linear moves to your DSLR or small camcorder video shoot. The aluminum V-slot style rail can support a load up to 26.5 lb. and may be used with or without the optional leg kit. The rail includes both 1/4"-20 and 3/8"-16 threaded center holes for mounting to single tripod. The 14" Single Rail V-Slider is compatible with Rat Rig's motorizing kits (not included). I sometimes use a Neewer Black Aluminum Alloy Quick Release QR Plate Adapter with 1/4"-3/8" Screw and Bubble Level for DSLR Camera Tripod Monopod Stabilizer Ball Head with my Rat Rig Slider

LED Video Lights

LED Video Lights use LEDs to provide the continuous light output needed for video recording.

Some example types include:

Panel lights are usually not portable and have 900 or more LEDs. Panel lights take accessories such as a tripod stand and barn doors.

LED Spot Lights focus LED light into a narrow, more focused beam.

Ring LED Lights are circular and render a soft reduced-shadow look that bathes the subject in light. Ring LED Lights are flattering to skin tones which make them popular with YouTubers who make videos about using cosmetics.

Small, Camera-Mountable LED Lights use about 200 LED or less. They can also be tripod mounted. These lights are battery or charger powered and can take filter accessories to produce diffuse light or to modify their color temperature. The brightness of their light output can also be adjusted.

LED Video Light Examples and Tips

I'd like to share some information and tips on two small, camera-mountable LED lights that I've used to make YouTube Videos.

The Altura Photo 160 LED Video Light Kit

The Altura Photo 160 LED video light comes with a useful kit of accessories including a rechargeable Li-Ion battery, a battery charger, a frosted diffuser, a Tungsten (orange) filter, an adjustable hot shoe mount and a hard-shell protective

carrying case. The Altura Photo LED Video Light Panel Kit will work with most DSLR Cameras. It features 160 daylight balanced (5500k) LEDs. This light offers 8 levels of brightness plus an LED battery level indicator. This light is designed for battery power only.

My favorite is **the Neewer On-Camera Video Light** with 176 LEDs. This light takes battery or charger power. The brightness is easy to adjust accurately, and it can be mounted to a standard camera hot shoe as well as a light stand.

Light Stands, Diffusers and Reflectors

These accessories are helpful to light your subject evenly and without harsh shadows. Light stands, diffusers and reflectors are essential to studio lighting. There are versions that can be taken mobile and outdoors.

Light Stands – A light stand resembles a tripod. I use two 6-foot photography light stands to hold reflectors, diffusers and LED lights. They're very light weight and I use them only in my studio.

Diffusers - Large areas of white cloth that let pass only a portion of your light source. Diffusers are helpful in bright sunlight and produce a softer light with less harsh shadows.

Reflector – A reflector bounces light toward your subject. You can get away with one light source if you have a

reflector to bounce light into the part of the subject that falls in shadow.

3-Axis Handheld Gimbal Stabilizer

Three example brand models of handheld gimbal stabilizer are Zhiyun-Tech Crane v2, Moza Air 2 3-Axis Handheld Gimbal Stabilizer and the DJI Ronin-M 3-Axis Handheld Gimbal Stabilizer.

A 3-axis handheld gimbal stabilizer offers 360° rotation along all three axes. Look for button-powered continuous rotation along the pan axis and circular rotation along the tilt and roll axes. Handheld gimbal stabilizers are designed for DSLR and mirrorless cameras. Check the maximum weight capacity of any model you're researching. These stabilizers feature MCUs or motor control units. Cameras attach easily without any tools and full setup is quick. There are also models designed to work with smartphones.

A handheld gimbal stabilizer can be very useful for still photography. They are miracle workers for videography.

Photographic Accessories

About Gadgets

The hobby of photography can often lead to a life-long quest for more gadgets and better and more expensive hardware to support your expanding interests. I believe it's helpful to remember not to allow an interest in the latest gadgets to eclipse your efforts to improve your artistic and technical skills. Your knowledge of photographic concepts will often more than compensate for a lack of a certain lens or camera body at the time. Although I too am always planning a new photographic hardware or software purchase, I like to think that today's perceived lack of needed hardware will inspire me to take more creative pictures with the equipment I already have.

Photographic Filters

Photographic filters are an important accessory to your camera. They come in many shapes and can be made from glass or other materials. Filters are usually made of glass and they are held within a slim metal ring. They attach to your camera by way of threading at the very end of your lens.

The basic photographic filter is intended to be mounted upon the barrel of your normal, zoom, wide angle or macro

lens in a way that light entering the camera must first pass through the filter. Most photographic lenses will already have the treading needed to do the job. The filter's purpose is to modify light in some way as it enters the camera lens on its way to registering an image inside the camera. There are many reasons you might want to modify the light entering your camera. They relate to improving the quality of the image or to adding special effects.

State of the art image processing software allows you to modify any image to get improved results. However, the best image process begins with an original image that meets high standards. A filter will help you get the results you want from many situations.

Photographic Filter Facts

Some Negative Factors - Learn how to use filters properly or else they could ruin your pictures. Also, filters add to the cost of photography, complicate the process of taking a picture, and make your camera bag heavier and more cluttered. Also note that some types of filters actually reduce the amount of light that enters your camera so that more light is required or more compensation is needed in the form of increased aperture and/or slower shutter speed to take pictures.

Why Use Filters? - Filters will improve the quality of your photos. Some filters can reduce haze. Some can remove surface glare and make the sky as blue as it looks to your

eyes. Some filters intensify the colors in your photos. Others can bring sparkle to parts of your photos or add other special effects. There are even some that can improve your photos while protecting your expensive camera lens.

Educate yourself about photographic filters. As with all equipment and gadgets, learn to get great results from your photography work without wasting money on items you don't really need. Read your camera's manual to see if it can take filters. If you lost the manual, look for threading in the metal around the front end of the lens surface. You may also find a printed number there, usually followed by "mm" (millimeters), that tells you the right filter size. Don't go out and buy a filter until you know what size your lens requires.

Not just any filter will fit any lens. For example, the normal lens for my Minolta is also a macro lens. It takes 55mm filters. It would not be unusual for the telephoto lens and the

wide-angle lens for the same camera to require different filter sizes. This will most often be the case when the lenses are not purchased from the original manufacturer or when you have purchased additional cameras over the years. Different brands of lenses and cameras will take various sizes of filters. One answer to this issue is called a "converter". In the best example converters may allow you to use one set of filters on all your lenses.

Selected Filter Types

Skylight, Haze & UV Filters - These filters do not require exposure adjustment. They partially block invisible ultraviolet light that is a natural part of sunlight. Although this light is invisible to us it's effect can be seen in your pictures as an excessive blue cast in shaded elements of the scene and poor contrast. When there is haze it can negatively impact your outdoor shot. The effect of haze is most noticeable with telephoto lenses. These filters can also reduce atmospheric haze in your pictures.

From my experience, the skylight filter is most useful when kept on the lens at all times. Many people prefer to use a UV filter this way. The skylight will serve to protect the top lens element from normal wear and reduce the possibility of impact cracks. It was a skylight filter that took the hit and cracked when I dropped my camera bag on a rock. That $12 filter saved my 200mm telephoto. You can't count on this protection in all cases but when it happens you feel pretty smart for having the filter in place.

Neutral Density (ND) Filter - This filter is used to intentionally reduce the amount of light entering your lens. The effect is helpful when you want to limit depth-of-focus in a bright light situation.

Fluorescent Light Filters - will help improve the greenish cast from fluorescent bulbs. Results are not 100% because of the various types of florescent bulb. However, you should expect to achieve more pleasing skin tones and more natural color rendition.

Color Filters - Color filters are most commonly used to enhance B & W photos. For example, a red or orange filter can make for dramatic black and white photos with exposure balance between sky and land. If you use a color filter with color film, you'll get an overall tint that can be considered a special effect.

Polarizing Filter - This filter reduces glare. That may not sound like much at first, however, the polarizing filter is very powerful and rewarding to use.

What about glare? - For our purposes I will define glare as light reflected from the surface of a nonmetallic object. Such light is reflected along a single plane. The polarizing filter can be rotated in its mounting to an angle where glare is blocked. This effect seems much more significant if you must ask yourself why the landscape pictures you took on that clear October day lack the sharpness and depth of color that you saw when you decided to take the pictures. The glare

effects occur largely from factors over which you have limited or no control, such as the angle to the sun and the composition of the very top surface of the object you are photographing.

Glare negatively affects the quality of many photographs taken in natural light. Pictures taken by incandescent light indoors can also be affected. Surfaces that commonly produce glare include bodies of water, windowpanes, and treated wood surfaces. Another common source of glare is air. Actually, it's the dust particles and droplets of water that are suspended in the atmosphere all the time.

The glare-blocking effect of a polarizing filter reduces unwanted glare in a photographic image while intensifying colors in your photograph. This filter is designed to be rotated according to the current light conditions. You can check through the viewfinder of a Single Lens Reflex camera to determine the exact effect of the filter and to experiment in real time as you desire.

Some benefits of a polarizing filter:

a. Blue skies that become a much deeper and more intense blue. This difference is easily to see.

b. Increased control over photographic situations such as more latitude in choosing your shooting angle and better matching of the sky to the ground features.

c. Improved detail, depth and contrast in wood grains and in the color patterns of wood in items such as a rifle stock, a desk or a wooden carving.

d. Picture elements such as the leaves of a tree and other foliage will reveal their true colors and patterns to a polarizing filter.

e. Shoot a lake scene and actually see a few feet into the water if it's clear enough.

f. Haze that is reduced more than with a UV or Skylight Filter.

Polarizing filters I have used consist of a rotating collar that can be smoothly rotated to the angle that is required to block unwanted glare. A well-made filter will also maintain its setting while the picture is taken and will have a small handle that makes the process easier.

On an overcast day the polarizing filter will have no effect. However, when the sky is blue or partly cloudy you can get a dramatic difference. It is important to remember that time of day (another way to say the angle of the sun) makes a big difference to how much a polarizing filter can improve your photos.

Photographing in sunlight from the street through a jewelry store window toward displays inside is a scenario that will demonstrate the problems glare presents when you try to shoot through glass. Frequently in this situation you would

barely be able to see the actual jewelry due to the glare in the window glass from the street behind you. The polarizing filter will frequently be able to remove all the glare and reveal the detail your subject.

Notable Considerations for All Filters

The first thing you may say when you try any of these filters with your pictures is something like, "So . . . that's how the professionals do it!"

However, not every filter effect will show in every picture and not all cameras will work well with filters:

a. If the sky is an important element of your photos, learn to shoot the sky when the sun is at the best angle to produce the polarizing effect. If the sun's angle is too shallow the polarizing effect will be minimal to unnoticeable. Your adjustment ring may not always be able to compensate fully. Again, when shooting outdoors on sunny days you'll get your best results before 10AM or after 3PM.

b. A Single Lens Reflex camera is best suited for efficient use of filters.

c. Exposure will have to be increased to compensate for the light loss through some filters such as a polarizing filter. Therefore, you will be less likely to use these filters when stopping high-speed action or in low light conditions.

d. Using a polarizing filter can over-saturate a blue sky to the point that it looks very unnatural.

e. Filters that intentionally distort light, such as a starburst filter, can be great fun and will give interesting photos. Some people like to take all their original shots with the best possible quality and add such effects through photo editing.

Video Cage for DSLR and Mirrorless Cameras

Your bracket should be sturdy and easy to grip. Most are made from aluminum alloy and have a handle grip. They improve stability and make following your subject more easily. A bracket is helpful for low angle shots. They also have mounting holes for attaching other accessories such as hot shoe adapters and a quick release plate.

Batteries

Shooting stills or video can require a lot of battery power. I say use wall plugs for cameras as much as possible and have back-ups for all camera batteries that are the exact type recommend in the camera manual. Use wall power for lighting when available and keep a good supply of the recommended battery type charged. The most common battery type is currently Li-ion also known as Lithium-ion.

The Extended Photographic Process

Photo Editing

Photo Editing Software

I prefer the term *image processing* software as an analogy to word processing but the term 'photo editing' software is used most often. I use PaintShop Pro most of the time and next often Adobe Photoshop. I believe many professionals prefer the various Adobe software titles.

This is a good time to talk about the problems we can create when messing with our most precious photos. Using word

processing as an analogy, I know one guy who saves every version of every document he has ever composed. He learned the miracle of 'save as' but is now encountering the problems. He wastes a lot of time finding the absolute latest version of his work and sometimes he picks the wrong document. That causes problems. Other people edit documents and never preserve the original. They keep overwriting with newer versions. That's like driving a car with no reverse.

My advice is to make the preservation of your original photo a top priority. Most software leaves it up to you. When experimenting the best precaution may be to make a copy of the photos you want to modify in a new directory called 'working copies' or whatever.

Image sources for Photo Editing

a. Transparency (Slide Film) - You will use a scanner with a transparency adapter to capture your photo into an image file.

b. Negative (Film) - You will use a scanner with negative scanning capability to capture your photo into an image file. Most transparency scanners can also do negatives.

c. Print (Film) - You will use a scanner to capture your photo into an image file.

d. Digital - You will transfer your image file from your camera.

Archiving You Favorite Shots

If you have transparencies, negatives or prints that are irreplaceable you should seriously consider 'archiving' them to a digital format. Non-digital media are subject to several forms of degradation over time that relate to fading, dyes and mold as well as to physical damage such as scratches and dust particles from accidents and even from normal handling.

Photo Management Software

These are examples of apps that help you organize, tag and search your photos. These functions become very useful when you accumulate a large number of photos.

Adobe Bridge - Adobe Bridge is a digital asset management app made by Adobe Systems. It is a component of Adobe Creative Suite. Adobe Bridge is used to organize files, assign colored labels or star ratings, edit embedded or associated XMP and IPTC Information Interchange Model metadata, or sort or categorize them based on their metadata. This is not a photo editing app.

Google Photos - Is for Android or iOS. Back up unlimited photos and videos. Up to 16MP and 1080p HD. Access them from any phone, tablet, or computer. Your photos are organized and searchable by the places and things in them.

Basic Photo Editing Tools

Photo editing methods require practice to get the best results. Use them sparingly and always work from a copy of your photo. The choice of a photo editing tool is often a judgment call. Don't hesitate to use 'undo' if you don't like the results. I prefer software that shows the effects my changes are making to the image while I'm are working with them. Some of the commonly used tools found in most photo editing software include color balance, color saturation, contrast, crop, resize and sharpen.

Color Balance Adjustment - This basic software tool often appears as slide bar that travels between orange and blue. In one direction the red/oranges in your image are enhanced and the blues diminished. Take it in the other direction to reduce the red/oranges and increase blues. This tool can

make a noticeable difference. For example, if your image has outdoor shadow areas that appear with a blue cast you can try to fix the problem by adjusting the color balance. With Adobe Photoshop there are 3 scales that travel in the color ranges for Cyan - Red, Magenta - Green, and Yellow - Blue.

Excessive blues are common to photos that contain haze and shadows. Color Saturation Adjustment - This tool will deepen the colors in your image making them more intense. Overdo this one and your image will look unnatural and unappealing.

Contrast Adjustment - This tool helps you change the relationship between the light and dark areas of your image. When shadow areas are too light or too dark try contrast adjustment. When the photo looks flat try contrast adjustment.

Cropping - To crop your photo is to select one rectangular portion of the image to make a new image. You crop to remove unwanted picture elements or just to improve the image composition. The most direct way to crop a picture is to select the part of the picture you want to keep with a software tool that defines a rectangular area on your image that is resizable as needed. When you have selected the area you want to keep use the copy function to copy the selected area to the clipboard and then paste it as a new image. Some software will do this automatically for you after you have indicated the selection area.

Resize (Resampling) - When you resize a photo you are changing its width and height in terms of pixels, inches or centimeters. You will most often want to maintain the picture's width to height ratio (aspect ratio) to avoid image distortion. Basic software may not offer a choice of resizing methods. If you have a choice, then there are considerations you can explore. For example, resizing .jpg files can introduce jaggedness that is more noticeable in images with lines. Try Bicubic resizing to achieve improved results with your .JPG

Sharpen Adjustment - This tool is commonly found in photo editing software and will automatically sharpen your entire photo or a selected area making edges clearer and often improving the image appearance. You can sharpen pictures that are to appear on a web site or in social media.

Software Titles

Examples of photo editing software include MS Paint 3D, Corel PaintShop Pro 2019 and several popular Adobe Photoshop titles. Paint. NET is a great example of a free 'image and photo manipulation application' for the Windows operating system. This software supports layers, unlimited undo, special effects, and a wide variety of useful and powerful tools. Originally intended as a free replacement for the MS Paint software that comes with Windows, it has grown into a powerful and easy to use tool for photo and image editing.

Color in a B & W Image

You see it in music videos and commercials a lot. I call this the Schindler's List movie effect. Although Spielberg didn't invent the effect, he sure did make it into a gimmick. It's the part where Schindler is looking over a horrible scene of people being rounded up by German troops. One little girl runs into a warehouse unnoticed but Schindler notices from the hill where he is observing from horseback. It's brought back one more time later in the movie. This is a B & W film, but the format and mood are broken because the little girl's coat is a rose-pink.

I suppose this insures that, even while chewing popcorn, you won't miss what the director wants you to see.

Focal B & W Effect

For this effect you need a color photo. You can set the size of the circular effect and the 'sharpness' which means how strong it is. This effect works best with a circular element or one that is placed in a corner of the photo. The application of

this effect highlights an area of your photo. You choose how subtle you want the effect to be.

The Traditional Method

Editing Images on Film - Before digital cameras became the standard, home photo processing was all about utilizing chemicals and a dark room to

develop film. This process included steps that are still recognizable today as photo

editing steps such as adjusting color values and improving image contrast.

The need to crop unwanted elements from a composition had to begin in the darkrooms of the first B & W photographers back in the middle 1800s. Some people are still making the effort to learn to use items such as photographic papers, enlargers, trays and stop bath to get the image results they want. The main drawback for most of us is the expense of good equipment as well as the cost of supplies ongoing. There are also problems with setting up a sink and darkroom at home and then breaking them down so other people can use the space.

Still it's a great way to learn useful skills in photography and a great way to learn ways of thinking about light and composition. Much of what you learn will remain valuable in your work with digital media.

Image File Formats

Since we have explored photo editing, we should also discuss the computer image file formats available to us and consider why there are so many file formats. When you are ready to save an image, you're confronted with the decision of which format to use and image compression options.

Image file compression can be lossless or lossy. The lossless compression methods preserve a perfect copy of the original.

That's exactly what you want. Lossy compression should be avoided for originals. Note that several file types that are thought of as lossless can be optionally set to provide file compression.

Image file formats that can be lossless, if you make the correct settings, include .TIFF, RAW, and .PNG. .JPG files are most often lossy. This format is a common image file format in digital cameras or is available as a format for saving files on your computer. It's usually ok to work with .JPG at this point, if you prefer. When you save the image, set for minimal compression. In this case you won't notice any degradation of the image. Be certain that your software allows for adjusting the compression factor and learn how to use this function. The .JPG file format will become very useful after you have your favorite originals safely saved in the best quality format possible with your software.

The basic trade off you should consider is the continuum of higher image quality and larger file size versus smaller file size and reduced image quality.

When you have the version, you want to save in your computer or make prints from you have the luxury of saving it in an uncompressed format. When you decide to incorporate the image into a web site you will want to trim the file size through compression to insure the photo snaps onto the screen when the page loads. Most social networking sites will compress your picture file for you when you upload it to them.

Compression equals loss of image information. A small to moderate level of compression can provide benefits without sacrificing a noticeable level of quality. On the other extreme high levels of compression will destroy your image. The top image is a .jpg saved with 1% compression and then below with maximum compression. Your digital images are composed of many small single-colored square display elements called pixels. Compression artifacts are a visible distortion of the image which results from excessive lossy file compression.

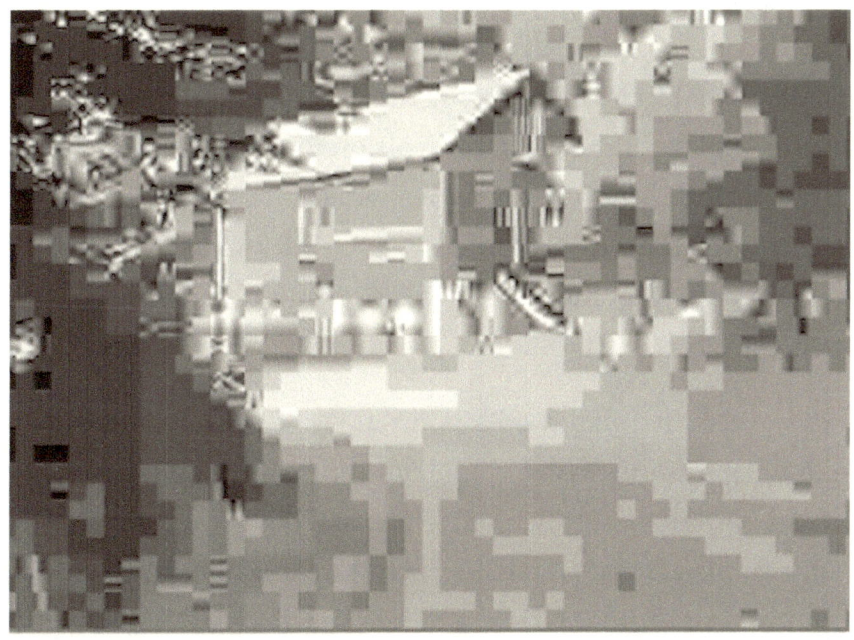

Pixelization from Too Much Compression

For online image presentation limiting the pixel count by reducing the dimensions of your image is one option that

may allow you to maintain acceptable image quality while still maintaining a smaller file size.

RAW Format - Your camera may be able to shoot photos in RAW format. RAW files are the best way to preserve your original image information in a digital file. Shoot in RAW mode to gain the most control over your final image. For photo editing Photoshop, Paintshop Pro and other photo editing software can handle RAW files. Check your program's feature list.

Camera Manual Walkthrough

I believe that there are many readers who would benefit from a review of the main controls on their point-and-shoot digital camera. In this section we will discuss the basic camera functions as presented in a typical camera manual. We can work together to gain better results from your camera.

I have recently purchased a point-and-shoot camera and the manual starts out with, "Thank you for purchasing our brand of digital camera. Before you start to use your new camera, please read these instructions carefully to enjoy optimum performance and a longer service life." So, this makes sense. Even if you jumped ahead and charged the battery and turned your new camera on 'just to make sure it works' you will be back to the manual at some point. The true manual is usually a PDF file provided on the CD or camera manuals can often be downloaded from the

manufacturer's web site. The printed manual may be limited to an explanation of how to install the battery and the memory card plus a lot of safety warnings in 5 languages.

I found this helpful advice at the beginning of my manual. "We recommend that you take test shots to get accustomed to your camera before taking important photographs. "Before you go out to take pictures take care of the 'housekeeping' tasks such as setting your language, time zone, time/date and all those first-time chores. I suggest that you also have a 32 GB or 64 GB flash card installed.

Some Buttons and Levers

Be aware of battery usage. When you are out on a planned 'shoot' you will want to start with a fully charged battery and you'll want the battery charge to last as long as possible. Keep the camera off when you aren't using it for extended periods of time such as when traveling between shots.

The zoom function of your camera may be controlled by a lever located near or on the shutter release button. Typically, the lever moves left for a wider-angle view and right to zoom in.

Shooting Modes - The Mode Dial

Your camera will likely have more modes available than we discuss here. Manufacturers tend to 'dumb down' these descriptions in the manual to the point that nobody can be sure what they are trying to say. So, I'll try to bring the

language back to a level where the descriptions are more useful.

Auto Mode - Full Auto Mode claims to automatically optimize all settings for the current scene. "The camera does all the work." As the manufacturer says, this is a good choice for beginners, but it also comes in handy when you're distracted or in a crowd of people and just want to be able to walk away with some acceptable pictures. While in Auto Mode you still must compose your shots and decide when it's time to push the shutter. The flash will also work automatically.

A or Aperture Priority Mode – As my manual says, "You control the aperture. You can sharpen or soften background details." What they mean is that through control of the aperture you can throw foreground and/or background picture elements out of focus while your main subject remains in sharp focus. We discuss aperture control in more detail elsewhere in this book. While you are selecting the aperture, the camera is selecting the shutter speed. Try to notice what speeds your camera is selecting. Use the aperture priority mode to help your subject stand out against a busy background. To accomplish this be careful with your focus and use a higher shutter speed while setting a larger aperture that the automatic mode would select.

S or Shutter-Priority Mode - You choose the shutter speed and let the camera automatically adjust the aperture for optimal exposure. Typical shutter speed selections that may

be available on your camera include 2 seconds, 1 second, 15th second, 60th second, 100th second, 400th second and 1000th second. A fast shutter speed can freeze a fast action scene without any blur. A slow shutter speed will blur a fast action scene. This blurring will give the impression of motion and you may want to try this slow speed effect on waterfalls and other flowing or moving objects.

M or Manual Mode - You choose both the aperture and the shutter speed. You are on your own in the selection of the optimal shutter speed / aperture combination required to achieve your desired result. However, you are not without the tools needed to measure variables such as light intensity and the distance to subject. There are ways to improve your results while using Manual Mode. To make Manual Mode work for you try taking note of what settings your camera would choose in Auto Mode for that scene and then manually make your changes from that reference point. You could also purchase a photographic light meter and even an electronic flash that includes a light sensor so that it can make its own light settings for the scene for fill-flash.

While shooting at slow shutter speeds, noise may appear on-screen. To reduce this noise, the camera activates the noise reduction function.

Choosing an Autofocus Target (AF target) - Read the camera manual to determine which button will cause the various autofocus targets to be displayed on your camera's display screen. Choose which of the autofocus targets will be

used as the autofocus target. I expect that your camera's default or original setting will be for the center square to be the autofocus target. You can leave that setting while you learn other parts of your camera's operation.

Flash Photography - Press the button that displays options. Choose a flash mode and make the selection. When the flash is lowered and closed by hand your camera will likely select Flash off.

Auto Flash Mode - The flash fires automatically in low light or for backlight conditions.

Red-eye Reduction Flash Mode -This function allows you to reduce the redeye that sometimes occurs when taking face pictures of people.

Fill-in Flash Mode - The flash fires regardless of the light conditions.

Flash Off Mode - The flash does not fire.

Wireless Flash Mode – Your camera may have the ability to use a second flash unit which will usually be placed off the camera. This second unit can function alone or in conjunction with your camera's flash to fill in light from a second direction to improve the evenness or coverage of light.

Another Consideration When using a Flash

Minimum Flash Range – The distance that must be maintained as a minimum separation between the camera and the subject in flash photography. Otherwise, the lens may cast shadows over objects close to the camera, causing distortion or the flash may be too bright even at minimum output.

My Photography Story

Getting Hooked

I'll dial *The Wayback Machine* to the mid-1970s. That's about the time I found my first full-time job which paid enough to allow me to become a true, though modest, American consumer. I came along at the end of eight-track tapes. It was a time when cassette tapes, component receivers and woofers were the leading edge in stereo. It was also near the time I bought my Atari 2600. That was impressive!

I was only mildly interested in photography at the time. I had an old camera that had been in the family. Probably a Kodak Brownie. The first camera I bought on my own was a Kodak 126 (cartridge) "Instamatic". That was all I needed for what I was doing with photography.

One day I was walking along 12th street and saw some interesting objects in the display window of a family run optician practice. They looked like they might be cameras, but I couldn't tell for sure. I walked inside and spoke with an old guy who probably owned the place. He explained that they were 35mm SLR cameras. To me they seemed to be a type of device sent from another planet.

The guy explained how they worked but I didn't understand what he was saying or what it had to do with taking pictures. He showed me a Japanese Ricoh and a German Leica. They had a weight to them and a metallic feel. There were orange and white numbers marked on a large lens barrel and a small housing at the top. Looking down through the lens I could see it was amazingly complex with many components hiding down there.

He explained that the lens was actually composed of about 6 to 8 high quality glass elements that were organized into groups which functioned to manipulate light rays of various properties to all come to focus at one place. Impressive!

Then he showed me where the flash would attach, where the camera body attached to a tripod and how the lens could be removed and changed for other lenses with other optical capabilities. Then he showed me the price tags. Being a small business, I understand now that they were charging close to full retail. I couldn't imagine how to justify paying that much for a camera. My Instamatic had cost less than $25.

This is long before the Internet. I began reading magazines such as Modern Photography and Popular Photography to learn everything I could about those 35mm cameras and about what was happening with photography in general. This all generated within me a great desire to own a modern camera that would help me demonstrate my artistic talent

and viewpoint to the world. I also learned about places such as 47th Street Photo and B & H Photo which featured deeply discounted mail order prices and more brand names such as Pentax, Minolta, Nikon, Olympus and Canon.

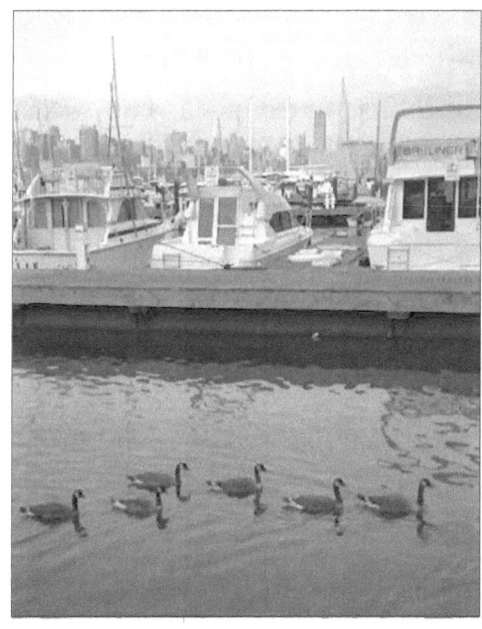

I settled for a Konica 35mm rangefinder for my first purchase. It bridged the gap well while I taught myself more about photography and saved up for the best SLR I could afford. The results of the multi-element lens did not disappoint. With this basic but good quality camera I learned about lens filters, tripods, flash photography and the properties of 35mm film.

I preferred to shoot transparencies. It was with the film with which I could afford to be a true American consumer thanks to Kodak. I tried a lot of other brands, but I always came back to good old Kodachrome and Ektachrome for transparencies and Kodak brand print film. The Kodak film products consistently delivered excellent results that rewarded the efforts I had made to take good pictures.

There was a time when I thought I wanted to go pro. I managed to sell a few shots to magazines as well as two photo essays with pictures and narrative about environmental issues. That was about the time I discovered that there is a huge gap between a good hobbyist and a professional. I figured that with an all-out effort I could gross as much as three of four thousand dollars a year. After subtracting a year's worth of equipment costs, transportation costs and allowing myself $1 an hour as 'salary', I could manage to be $5,000 in the red. Fortunately I didn't quit my day job.

Photography has held an important role as a hobby throughout my life. It's an essential portal that diverts me to the exotic mind set of creativity. It grants me a clear separation from humdrum daily routines. After all, I can't draw, paint, sing, keep a drum beat or play hockey. Returning to the present we find that film is almost history now. For many folks even cameras are history as their cell phones and other devices seem perfectly adequate for taking and sharing pictures. Still, it seems that they very much enjoy taking those pictures regardless of the technology involved.

My Minolta SR-T 201 Film Camera

I made a video about using this old camera. For the video I attempted to use this camera which had not taken a picture in 20 years. There were many questions about how well it

would function optically, electronically and mechanically. film and installing a battery.

If you're trying to "renew" the SRT 201, the battery is a big issue. The original PX-13 mercury battery has not been available for a long time due to issues with mercury. For a while, batteries that claimed to replace the PX-13 were available for purchase. Unfortunately, these batteries produced the wrong voltage which made your exposure readings wonky. Now, I exclusively use the "WeinCell MRB625 Replacement Battery for PX625/PX13" because it's performance matches that of the PX-13 very well.

For the renewal video I chose to feature Ilford black and white film. The processing was included in the price and everything worked perfectly. More About the Minolta SR-T 201 Film Camera

This camera was purchased in 1977. Your first impression of the camera would be that it's relatively small, but with a heavier feel than today's DSLR cameras. This camera contains more metal and less plastic than modern DSLR cameras. I used this camera with an MC Minolta Celtic 50mm, F 3.5, macro lens and an MC Minolta Celtic F 4.5, 200mm telephoto lens. The macro was great for all kinds of close up shots and it also doubles as my normal lens.

Here are some commonly used accessories from the time this camera was new.

We start with two polarizing lens filters. I've found polarizers with a handle to be much easier to use. Then there's the orange lens filter, which is used with black and white film to darken skies and enhance cloud effects. The viewfinder eye cup used to reduce flare and to make it easier to see through the viewfinder. This camera used a remote shutter release cable as well as the camera's self-timer to reduce vibration when using a tripod. The shutter release cable also locks making it useful for subjects such as fireworks and for time lapse photography when the camera's shutter is set at "B". Finally, there's the Soligor MK-10A electronic flash. This versatile and powerful flash unit could rotate horizontally and vertically and could be taken off-camera while maintain light readings at the camera's hot shoe.

THE END

www.ingramcontent.com/pod-product-compliance
Lightning Source LLC
Chambersburg PA
CBHW020919180526
45163CB00007B/2799